BRITAIN'S LOST
HIGH
STREETS

AMBERLEY

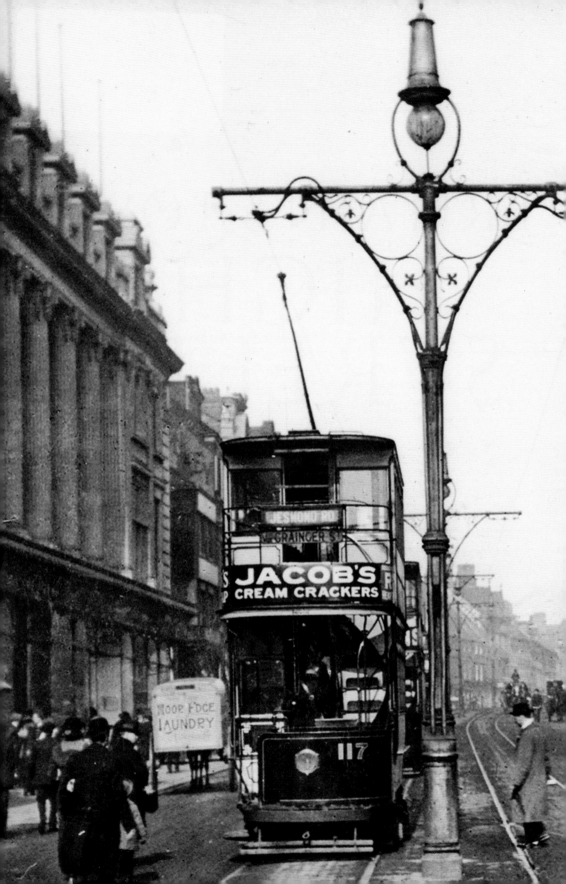

SARAH KENDALL

BRITAIN'S LOST HIGH STREETS

Overleaf: Taken in 1908, this postcard may as well be an advert for Jacob's Cream Crackers. It gives great prominence to both the electric lamp post and the tram, both signs of great technological advancement at the time.

First published 2014

Amberley Publishing
The Hill, Stroud
Gloucestershire, GL5 4EP

www.amberley-books.com

British Library Cataloguing in Publication Data.
A catalogue record for this book is available from the British Library.

ISBN 978 1 4456 4360 1 (print)
ISBN 978 1 4456 4395 3 (ebook)

Typesetting and Origination by Amberley Publishing.
Printed in the UK.

Contents

Getting Around

The British high street has always been a major thoroughfare, providing access to shoppers as well as a way through the centre of town. The way we get around our towns and cities has changed dramatically over the past two centuries, from the ongoing changes in transport type to the way we use the high street itself.

While many high streets today are pedestrianised or limit access for vehicles outside of certain hours, many also form part of the main route for commuters, causing congestion and often necessitating the use of traffic control and calming systems. The rise of the motor car and subsequent growth of Britain's roads has seen a dramatic surge in traffic on the British high street. Public transport has grown, too, with bus and tram services becoming ever more frequent. In fact, the use of trams, once far more widespread, has come full circle as councils reintroduce tram systems into cities all over the country. Taxis provide shoppers and residents with further options but the private car, once a privilege that could only be afforded by the wealthy, is now a ubiquitous presence. Car parks built to cope with this problem still cannot prevent the high streets being lined with vehicles; pedestrian crossings are vital.

On the other hand, this change in town centre traffic has also meant a decrease in long-distance traffic passing through the centre. Gone are the days when travelling around the country was a long, expensive process. Before, coaching inns welcomed travellers to the centre of town, while today motorways direct the large volume of traffic away from populated areas; service stations provide food, fuel for the onward journey and often a bed for the night. The advent of the railway also contributed to the demise of the coaching inn; with journeys that once took days reduced to mere hours by train, the choice was obvious. This meant that many once-bustling inns were forced to close through sheer lack of customers, along with other businesses that would have relied on the passing trade. Eventually, towns and villages were bypassed altogether, and signposts at motorway junctions are now the only enticement to stray from the beaten track.

The Victorian high street, before the introduction and rise in popularity of the motor car, was nonetheless a main thoroughfare for local traffic. Horse-drawn carriages for personal use, along with the cost of keeping a team of horses to draw them, were expensive to purchase and maintain; places with a larger and wealthier population, such as London, saw a far greater number of carriages than did rural towns and villages, where there might only be a few families affluent enough to keep their own. Whether open carriages or more formal enclosed coaches, these were the height of luxurious personal travel before the railways and a privilege very much for the wealthier members of society. A lady visiting her dressmaker

in London would not expect to walk to her appointment, nor yet to share her carriage with others. A visit to the high street for our upper-class lady was an opportunity to see and be seen, and a private carriage could only have added to her consequence. In many ways, the attitude towards private travel was very similar to today's; the newer and more sporting or luxurious the model, the higher one's position in society.

Of course, the private carriage was not the only horse-drawn vehicle. Many businesses relied upon carts and wagons in order to transport goods where the railway had not yet reached, and door-to-door sales were the mainstay of businesses for those such as milkmen. These carts and wagons would have mingled with the private carriages in the high street, as would the simple vehicles belonging to wealthier members of the working classes. Horse-drawn transport was, of course, quite simply larger than the modern motor car, and that created its own unique problems. Drawn by one, two or sometimes even four horses, the chaos caused by a broken carriage or a wrong turn must have been significant!

For those who did not need or could not afford a vehicle, the hackney carriage – especially in London – was a good alternative; the direct ancestors of the modern taxi cab, these could be hired by anyone and were widely available. Otherwise, for a while the horse was still the best alternative to walking. Hired horses were available, and many workhorses belonging to farms or other businesses could also be ridden. By the 1890s, however, the bicycle was beginning to appear more and more on Britain's high streets as commuters and shoppers chose relatively light and easy personal transport over the myriad difficulties associated with hiring, stabling and even riding a horse. The introduction of the 'safety bicycle', with its air-filled tyres and gears, was so popular that it was the catalyst for many of Britain's high streets to be paved, allowing for easier travel.

At the turn of the century, the biggest change for Britain's streets in hundreds of years was to occur with the introduction of the motor car. At first they may have been a rare sight, a luxury few could indulge in, but by the middle of the twentieth century more and more cars were beginning to crowd on to Britain's streets. This further hastened the gradual demise of the horse-drawn vehicle. Trams and public buses were soon to appear in steadily increasing numbers, offering alternatives for the growing working and middle classes in an ever more mobile society. As living standards increased and people travelled further afield for both work and leisure, so the limitations of horse-drawn transport became apparent. Already far slower than the trains for travelling any distance, horses also needed either resting or changing for a fresh team on a long journey, along with the associated expenses of feed and care. The motor car was far more convenient; once parked it could be left for as long as needed, and without the need to find stabling. For the high street, it was more manoeuvrable, more convenient and more fashionable than a carriage, and offered the obvious advantages of space and comfort over the bicycle.

The growth in ownership of personal motor cars meant that soon, the streets filled with pedestrians and horses were a distant memory; an irrevocable change had taken place, and as towns and cities expanded, travel through the British high street took on quite a different flavour. The lone chauffeur-driven car awaiting its owner outside an exclusive boutique has been replaced by a row of modern vehicles lining the road, with parking time limited and heavily metered. The procession of farmer's carts into a town centre on market day has been replaced by endless bus services and rows of carefully programmed traffic lights. The only reminders of these lost scenes lie in the occasional preserved drinking-trough or in the very streets themselves, built wide to allow for the passage of horse-drawn vehicles in their heyday.

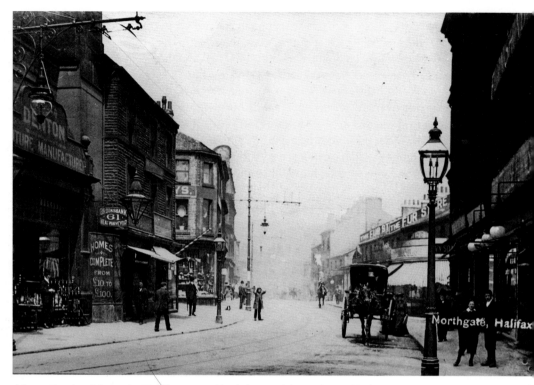

Above: Portland Street in Halifax, a vanished thoroughfare. The traffic here shows an open carriage and a lone rider, but note the tramlines in the street. *Below*: The corner of Broad Street and Northgate, also in Halifax. This was once a thriving area with a variety of specialist shops, which are now long gone. Note the delivery coach on the left, waiting outside what looks like a clothing store, and the approaching tram in the distance.

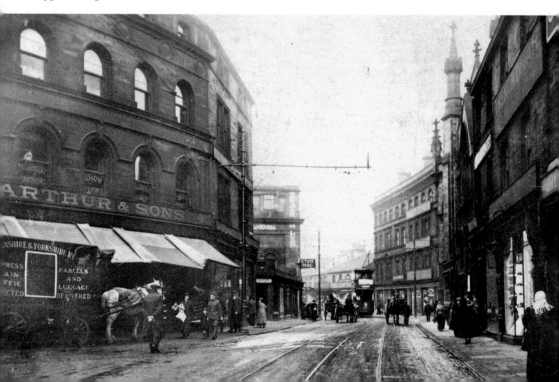

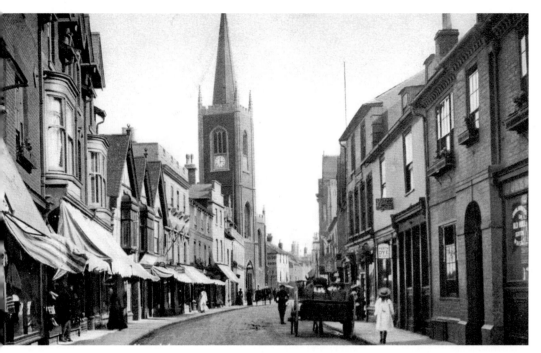

Church Street, Harwich. The canopied shop fronts and horse with trap show a scene from bygone times.

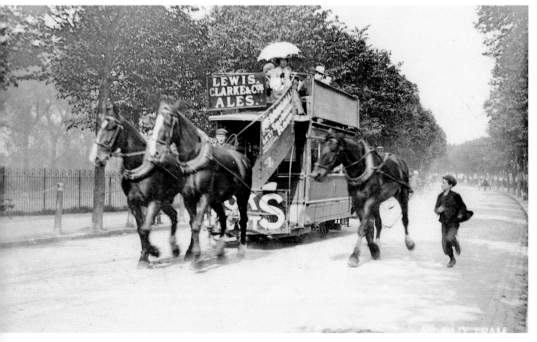

Horse-drawn trams such as the one above had appeared in Worcester by 1881. This two-horsed vehicle was introduced in around 1894; the additional horse was needed to haul the tram up steep inclines. This vehicle was much easier to draw as it ran on steel wheels along the tramlines; they were gradually phased out in favour of the electric tram in most areas.

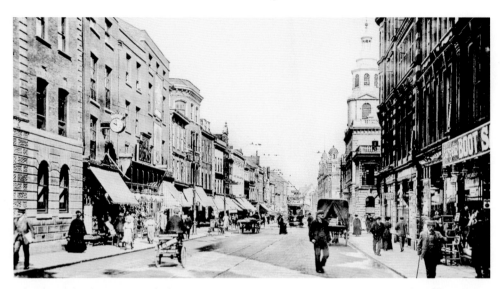

Above: In this busy view of The Cross in Worcester, we can see a mixture of traffic; a tram approaches through the carriages on either side, while in the foreground is a pedal-powered cart belonging to a fishmonger based at 37 High Street. *Below:* Shoe Shop Street in Halifax, always a busy thoroughfare. Horses and carts and carriages fill the street. It lies on the former packhorse road from Wakefield to Lancashire and was formerly called High Street.

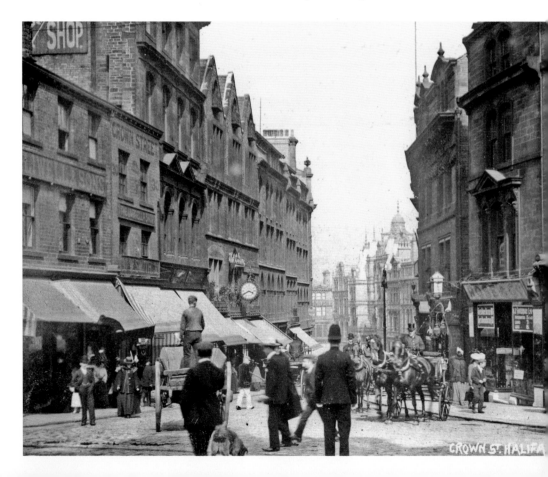

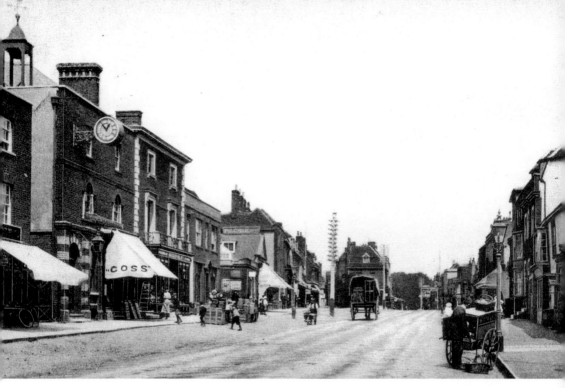

In this view of Witham's Newland Road (evidently considered to be the town's high street), what traffic there is seems to be on foot. A man pushes a barrow along the middle of the road and a street vendor seems to be setting up his wheeled stall on the right.

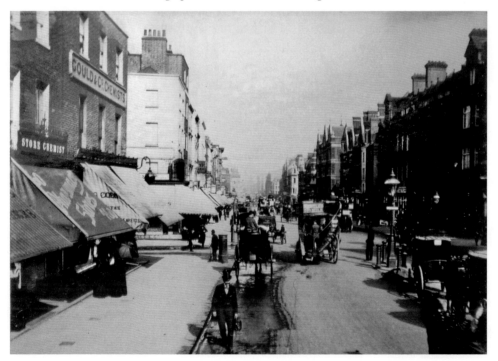

This view of London's Oxford Street from around 1895 shows an even busier scene, with horses and carriages thronging the streets. The capital city was known for its congestion even then.

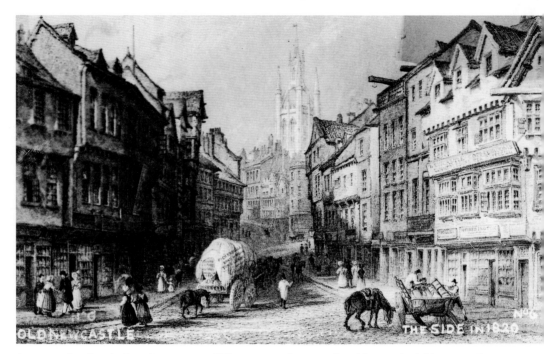

An engraving dated 1820 shows a very different scene from modern Newcastle. A big covered wagon takes up most of Dean Street, while on the right men are loading into a smaller cart and their horse feeds from hay in the middle of the road.

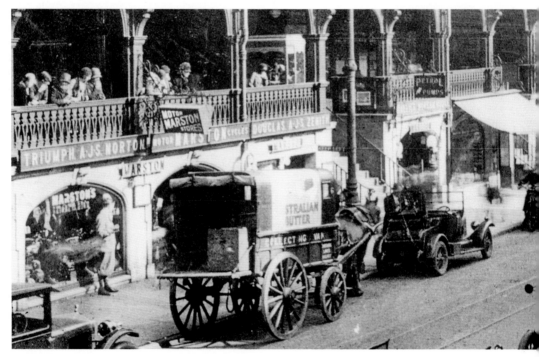

In this much later image from 1920s Chester, horse-drawn traffic is still used, but there are now far more motor cars. The shop to the left sells motorcycles and motorcycle parts.

WILLIAM DOVEY,

Cart, Van and Wagon Builder,

HORSES CAREFULLY SHOD.

Wheels New Tyred, and all kinds of Smiths' Work done on the Premises.

28 & 29,

SOUTHALLS LANE,

DUDLEY.

Many companies such as this would have been put out of business by the rapid rise in popularity of motorised transport.

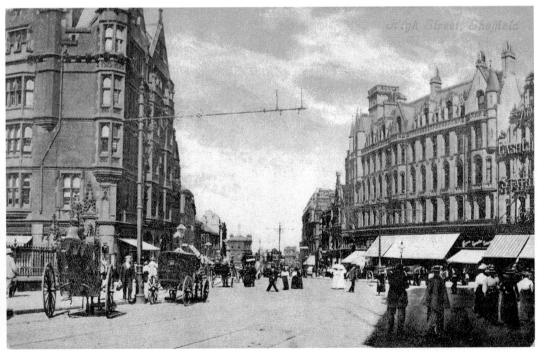

This postcard shows Sheffield's High Street in the early 1900s. The street is busy with both carriages and people, and tramlines have been laid.

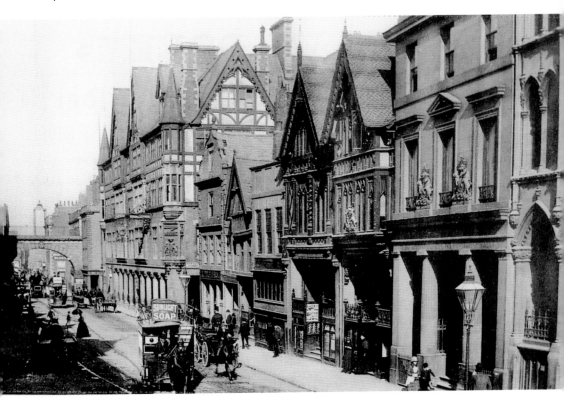

This image of Chester's Eastgate Street from 1897 shows a similarly busy scene, with a horse tram – sporting an advert for soap – in the middle.

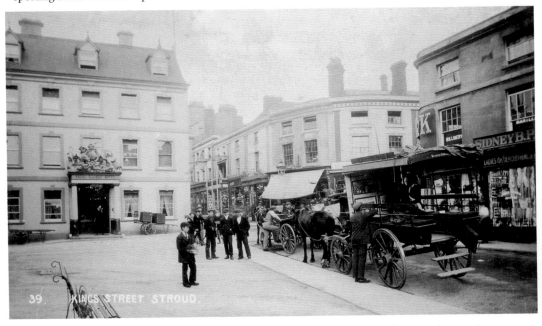

In this 1909 image of King's Street Parade, Stroud, a horse bus is waiting where modern taxis now stand. This mid-town stopping point would have been extremely well used.

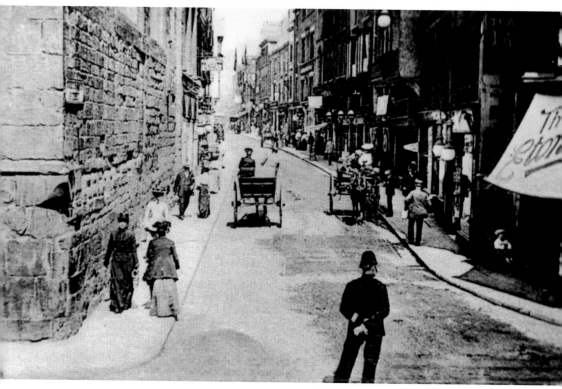

A policeman stands in the middle of Chester's Northgate Street to direct traffic. The image is dated around 1908.

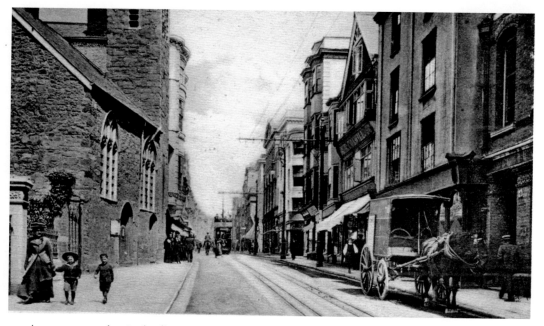

A tram approaches in the distance as a wagon labours past in this postcard of Exeter.

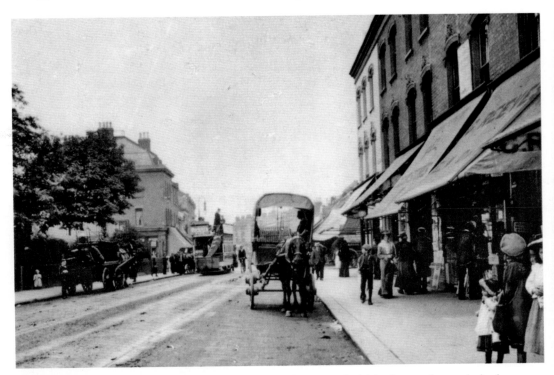

Leytonstone High Road is a busy high street, and in the foreground of this picture a horse plods along with a delivery cart, watched by children on the pavement.

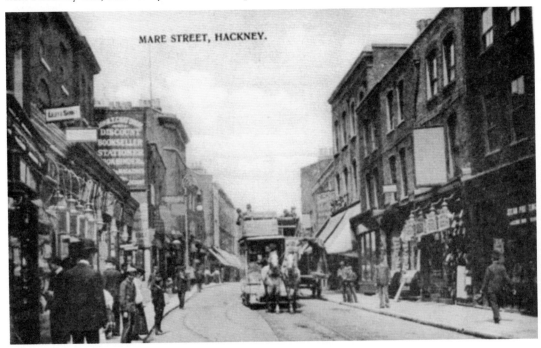

This picture of Mare Street, Hackney, shows another horse-drawn tram. The open-topped double-decker model was one that would continue to be used on omnibuses when they were introduced.

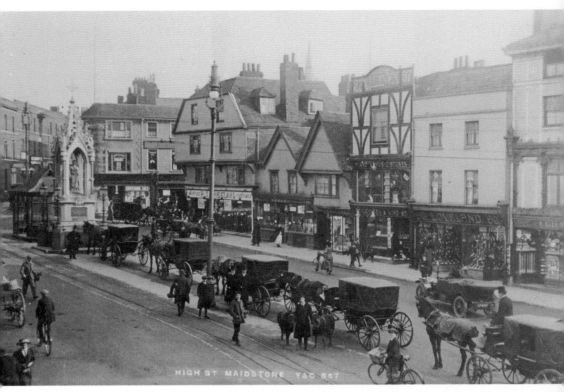

Above: Here, cabs queue in front of the Queen's Monument on Maidstone's High Street in 1912. Tramlines have been laid and there is a motor car in the background, but it is evident that the cabs were still doing good trade at this point.

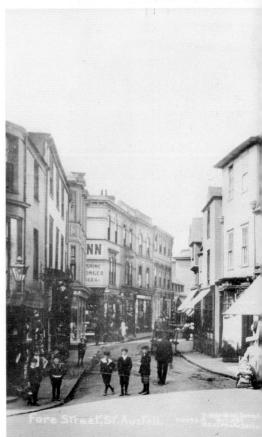

Right: In early twentieth-century Cornwall, tramlines had not been laid. St Austell's Fore Street has more pedestrians than vehicles; the three children in the middle of the road seem in little danger.

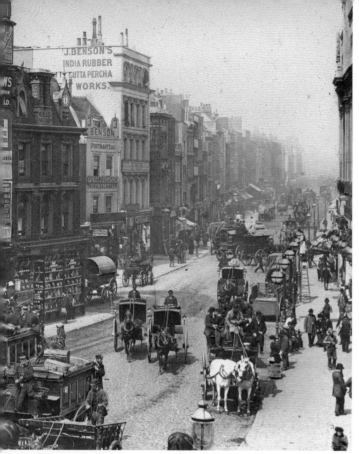

Left: London's Tottenham Court Road from Oxford street, a busy highway with many carriages. In the foreground is a travelling coach with luggage on top; London, then as now, was a popular destination.

Below: Corporation Street, Blackpool, in around 1905. A little girl chases after a horse and cart, a man pushes a handcart up the middle of the road and, in the foreground, someone has left a bicycle unattended – not advisable these days.

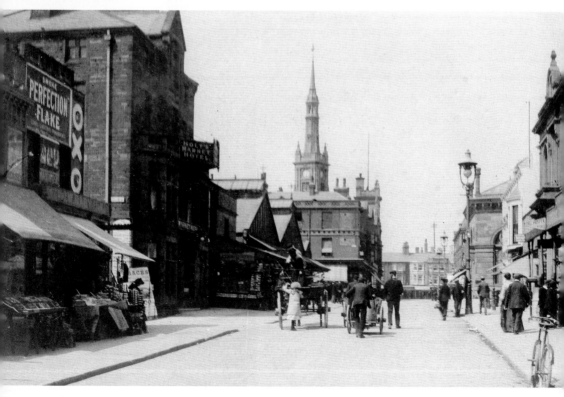

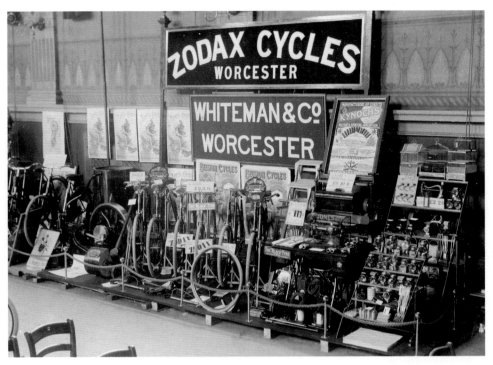

Whiteman and Company in Worcester, ironmongers and cycle agents, clearly catered for the cyclist's every need. The display also includes a sewing machine, lawnmowers, birdcages, mincers and other assorted items.

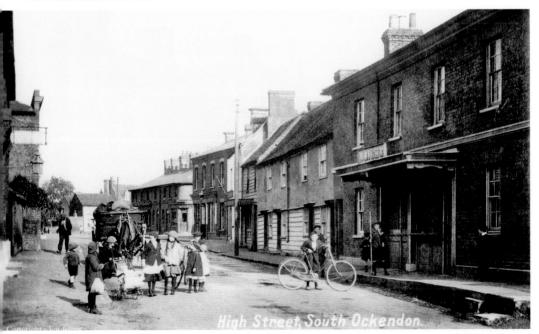

South Ockendon's High Street has a wagon piled high with sacks of grain and a young boy with a bicycle. It is rather too big for him but obviously an object of pride.

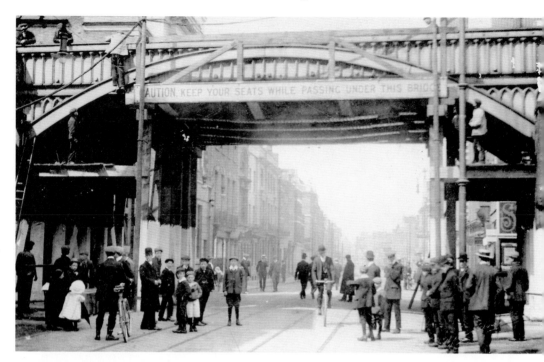

The bridge sign warns passengers on open-topped trams to keep their seats when passing under the bridge. The only traffic in evidence here, however, is cyclists.

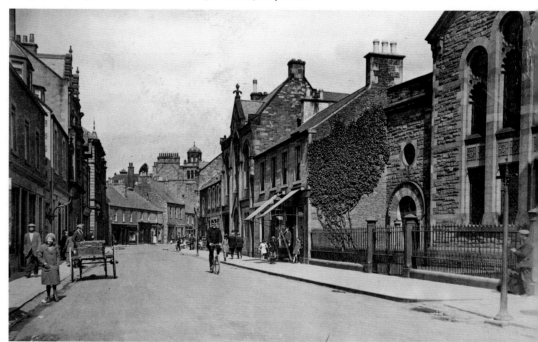

A light handcart on the left and a policeman on a bicycle are the only traffic on the High Street in Galashiels. There is now a pedestrian crossing here, testimony to the increase in traffic on this road since the photograph was taken.

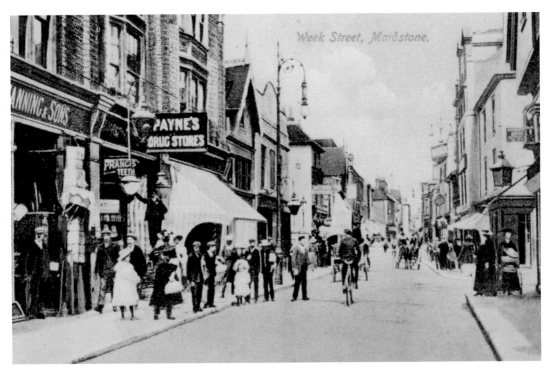

Above: Week Street was Maidstone's main shopping street in 1909. Horse-drawn carts and a cyclist here weave their way around pedestrians. *Below*: In this image of the corner of King Street, an early motor car can be seen; the area is very different today.

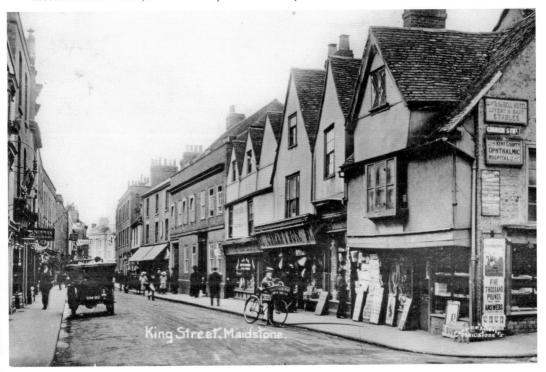

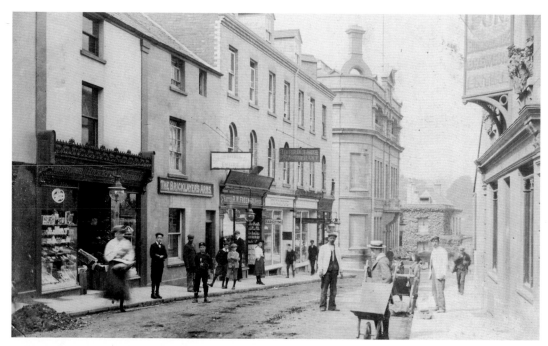

In this Edwardian picture of Stroud's Russell Street, handcarts form most of the traffic. A Post Office messenger boy stands by the kerb on the left, outside the Bricklayer's Arms.

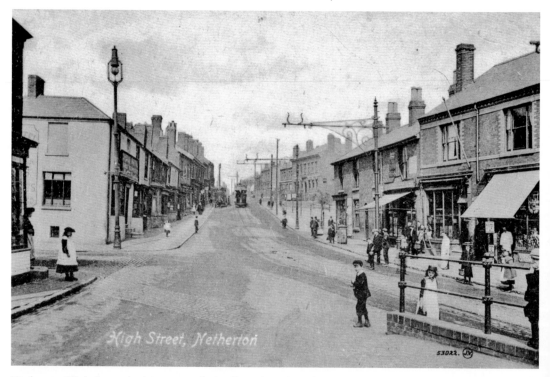

Netherton High Street, looking towards Dudley. There have been many changes to the buildings and this is now a busy road, although here it is shown almost deserted.

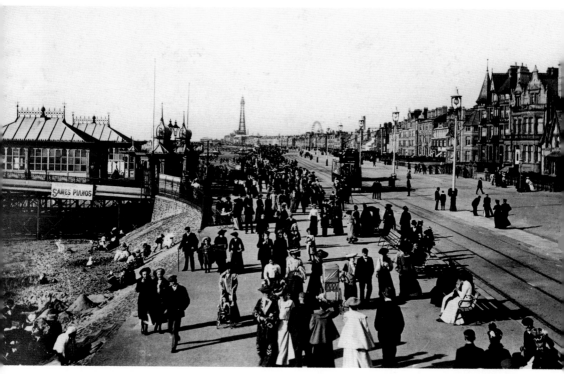

South Pier, Blackpool, around 1909. The trams are running, but strolling along the Promenade is definitely the most popular way of getting around.

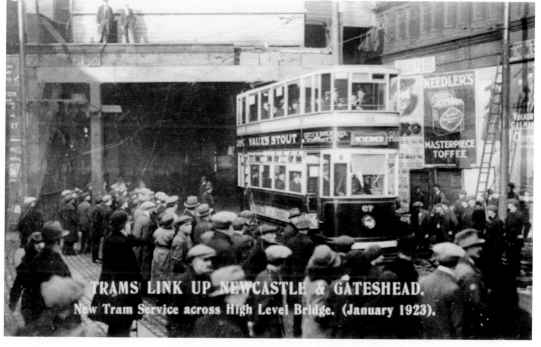

In 1923, the first tram service started between Newcastle and Gateshead.

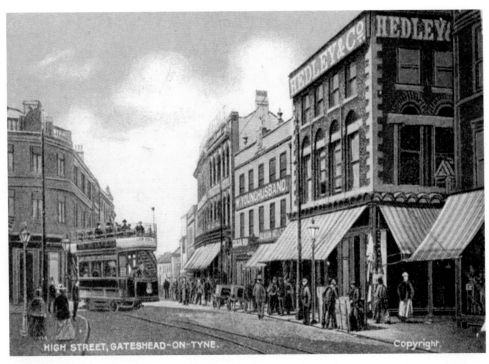

Gateshead High Street. The High Street has completely changed in modern times and is now a main route through the city centre. In both of these images, trams ferry passengers to busy shopping centres.

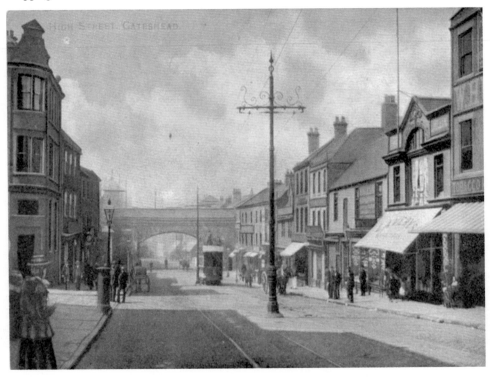

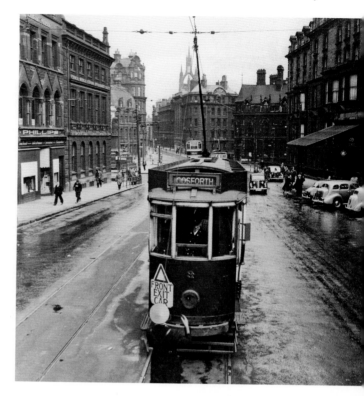

Right: A later Newcastle tram passing through on its way to Gosforth.

Below: A view of Newcastle's Blackett Street, taken from the top of Grey's Monument. The busy street is full of the signs of wealth and technological progression.

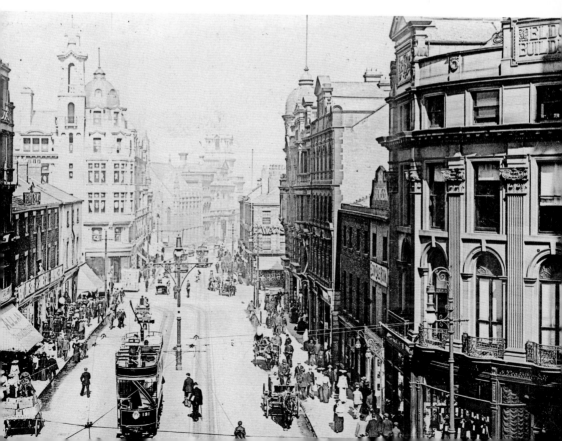

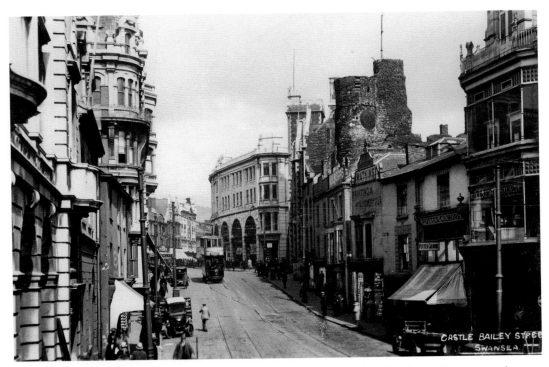

Above: Castle Bailey Street in early twentieth-century Swansea. *Below*: High Street. Shoppers make great use of the tram systems, while a few private cars and vans are beginning to appear; horses are still used for some heavy work.

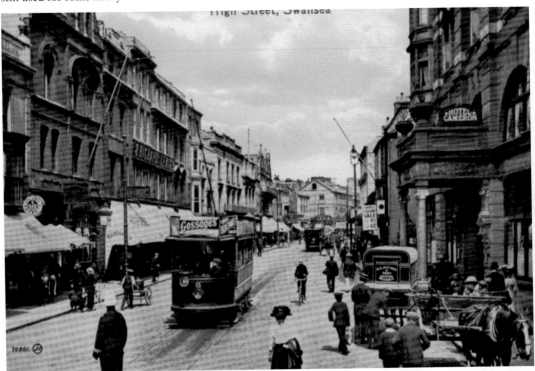

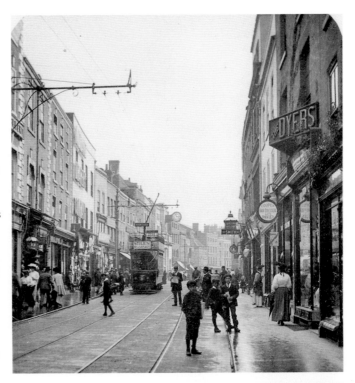

Right: Here we look south from Worcester's High Street in the early 1920s. Trams are again prominent and most pedestrians have taken to the pavements, but one gentleman in the centre still seems to be reading his paper in the middle of the road!

Below: An earlier image of Dudley's High Street, between 1900 and 1920, shows an all but deserted town centre; this has changed dramatically in the past hundred years.

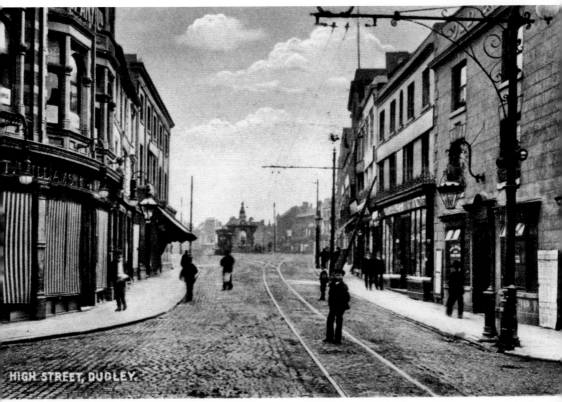

HIGH STREET, DUDLEY.

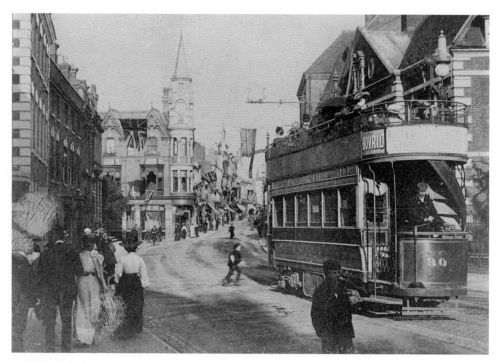

Wolverhampton Street in Dudley. The boy running across the road seems to be racing to catch the tram.

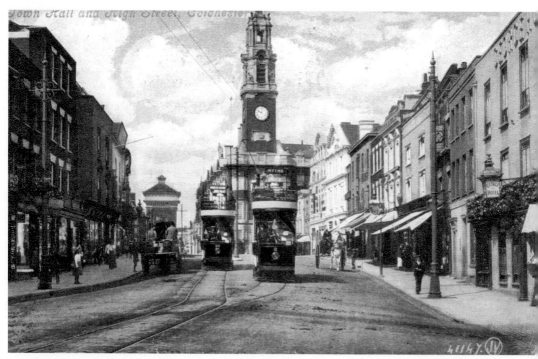

Colchester's High Street. Several of the old buildings in this scene have survived, but the traffic is of course entirely different.

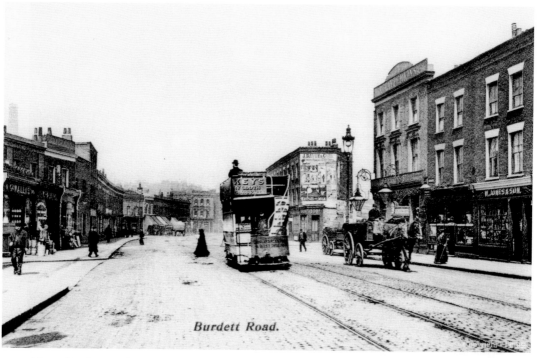

Burdett Road.

Above: Burdett Road in East London. In this early photograph, the tram seems to have one lone passenger.
Below: On the corner of High Street North and Barking Road in East Ham, the road is far quieter than one would ever experience today. Note also the Denmark Arms on the corner, which is still open today.

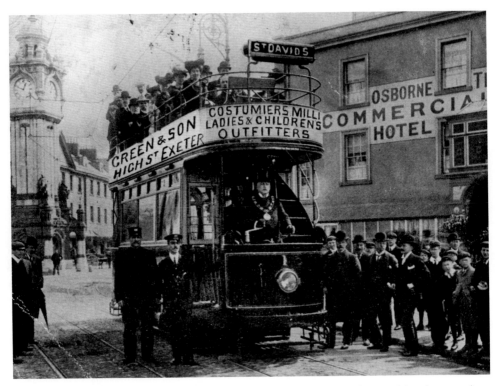

Exeter's first horse-drawn tramway was introduced in 1882 to initial opposition from traders, but proved a big success. When it was replaced by electric trams in 1905 this marked a big development and the network was extended. The service ended in 1931.

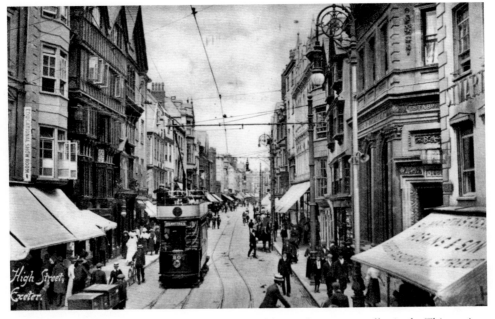

High Street, Exeter. Early cars, trams, bicycles and horse-drawn carts all mingle. This ancient street is almost unrecognisable today.

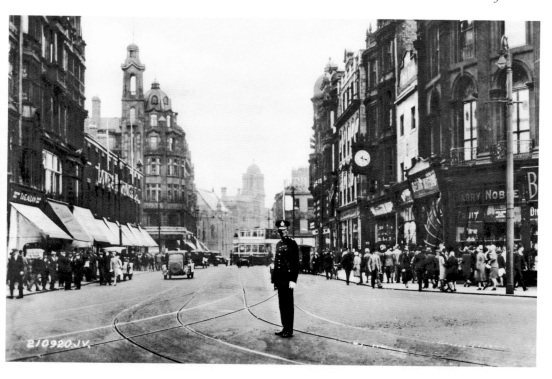

Above: Blackett Street, Newcastle. The roads are devoid of pedestrians apart from one lone policeman, directing traffic. *Below*: A tram in Grainger Street. Trams in Newcastle continued up until 1951.

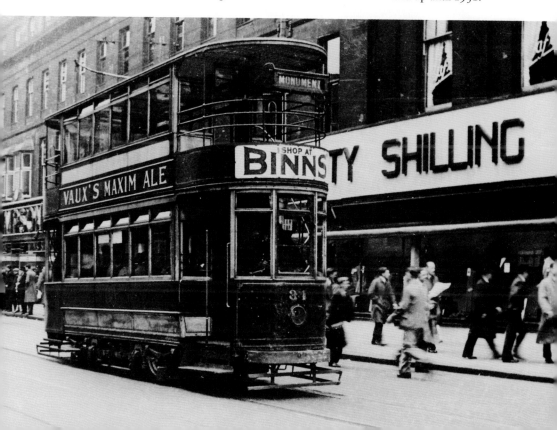

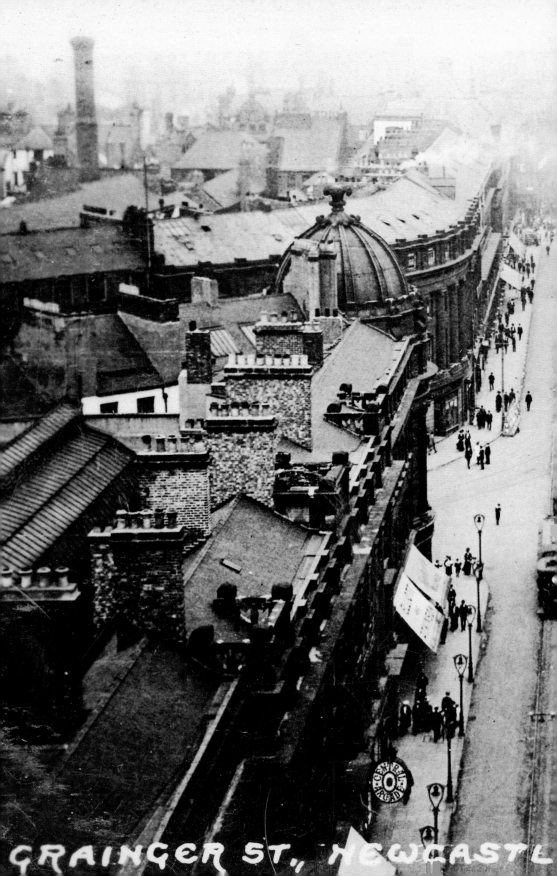

GRAINGER ST., NEWCASTLE

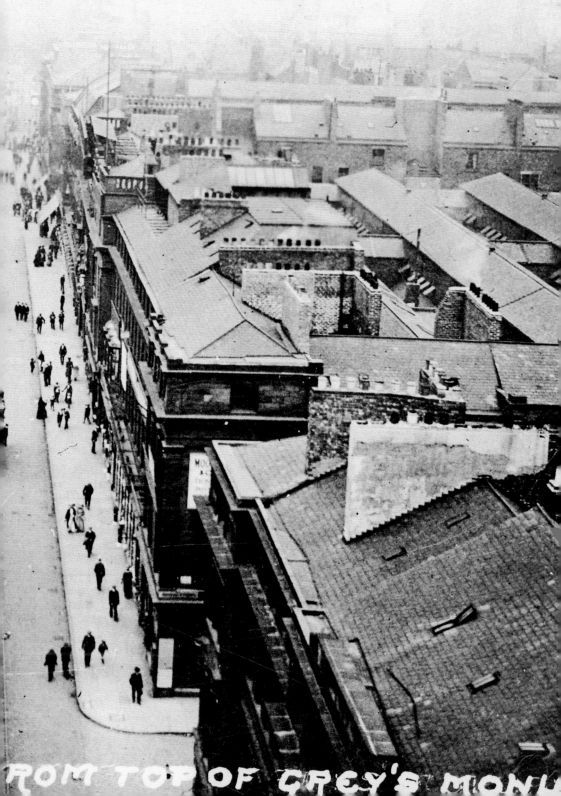

Another view of Grainger Street from the Grey's Monument, in around 1906. Trams and pedestrians seem to make up all of the traffic on this road.

ROM TOP OF GREY'S MONU

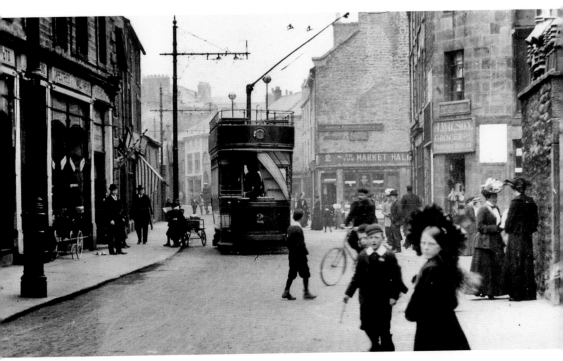

King Street, Lancaster, around 1905. The tram seems to fill the narrow street. There were tramways in Lancaster up until 1930.

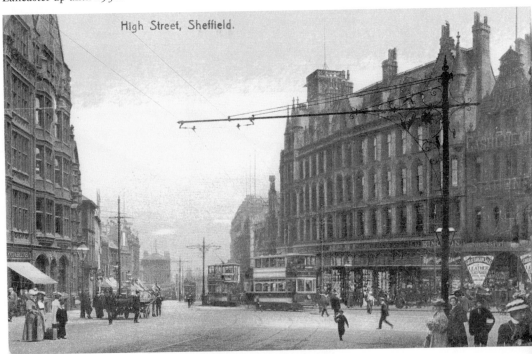

Sheffield's High Street. This 1908 postcard shows brightly coloured double-decker trams, along with a delivery horse and cart.

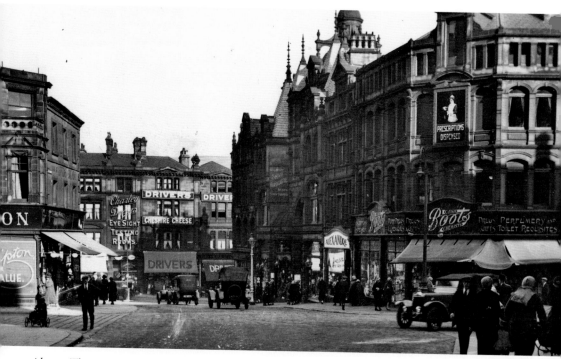

Above: The corner of Old Market and Corn Market, Halifax. There are several early cars in this picture, and note the boy driving the toy car on the left. *Below*: On King Edward Street, a car stands under the impressive architecture of the Arcade Royale.

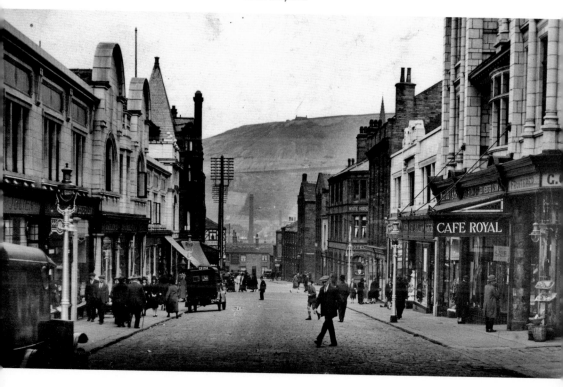

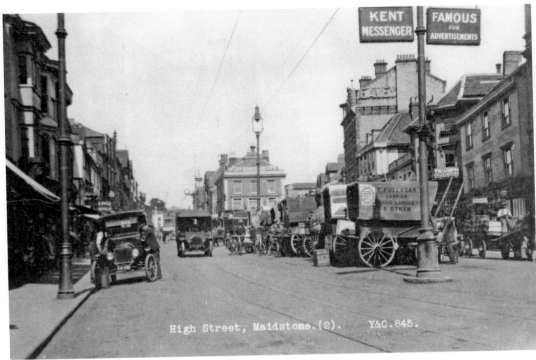

High Street, Maidstone.(2). Y&C.845.

Above: Carrier carts line up in the lower High Street in around 1906 in Maidstone; these provided a regular daily service to Maidstone from the outlying villages, but gradually disappeared as motor transport took over. *Below*: In the 1920s High Street, they have been replaced by taxis.

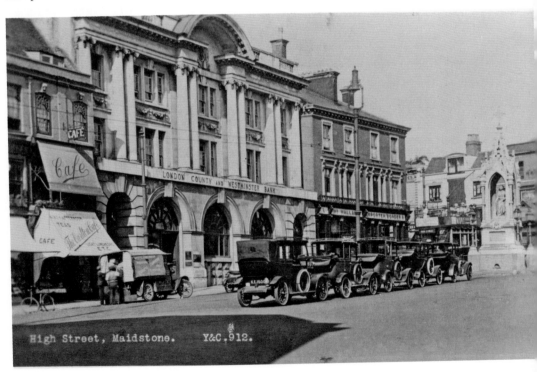

High Street, Maidstone. Y&C.912.

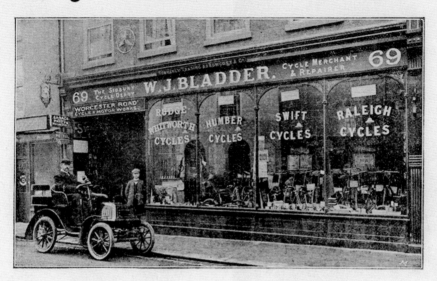

Above: An advertisement for a Worcester 'Cycle and Motor Works' shows an early motor car parked outside. *Below*: The Upper High Street. This was widened in 1903 for the new tramway system.

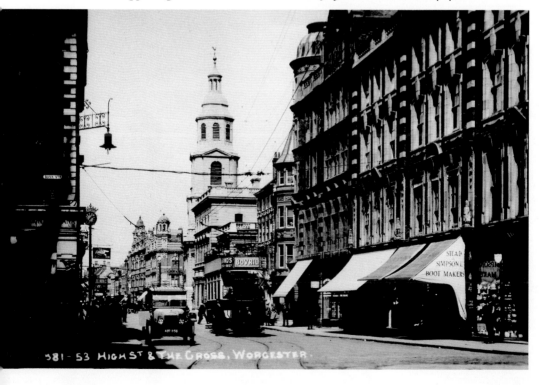

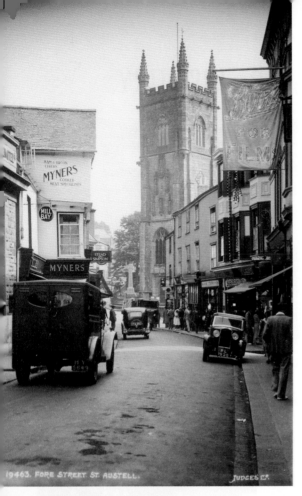

Left: St Austell's Fore Street in 1930 has plenty of motor traffic, in the form of both delivery vans and private cars, though there is evidence of horses on the road in the foreground.

Below: In Swansea's Castle Street in 1938, progress is a lot busier, with horses, cyclists, trams and motor cars all sharing the high street.

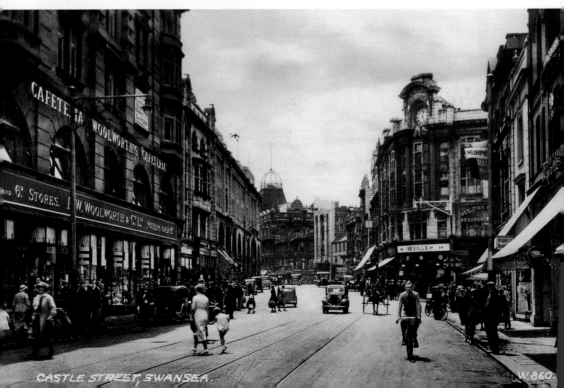

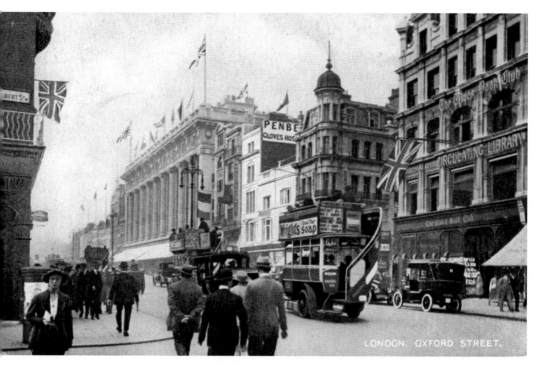

London's Oxford Street, around 1919. Few if any horses remain in this busy shopping street; public transport, then as now, is covered with adverts.

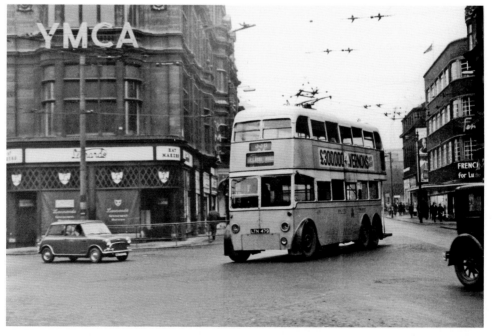

In 1960s Newcastle, the trams are gone, but the buildings in this photograph are soon to vanish as well. We can see one of the iconic Minis, and a glimpse of the rear of a much older vintage car on the very right.

SHOPPING

Take a trip to the high street today and it's often all too difficult to tell which town or city you're in. There's a lot to be said for universality – it's good to know that you can buy something in Edinburgh and return it to the same shop in Penzance with no problems at all – but something has nonetheless been lost along the way; when a relatively small selection of retailers dominate the high street, there is very little room for variety. Local businesses simply cannot afford to compete.

Once, the high street told a very different story. National chains, so common today, were very rare. A successful store might expand their business with home deliveries, or perhaps even shops in neighbouring towns, but to cover the whole of the country as so many chains do today was impossible without fast transport and communication links. Instead, the high street was full of independent retailers, serving a need often unique to the local people.

Shopping on the high street was almost a daily occurrence for many women. As the main homemakers, this was seen as their domain. Before the convenience afforded by refrigerators and freezers, perishable goods needed to be bought and then quickly consumed; storage on a long-term scale was impossible, and this meant frequent visits to the shops. Before the advent of supermarkets, too, these shops would have been far more varied. Butchers' and grocers' shops, bakeries and even dairies were a constant presence on the high street, all locally supplied and no doubt competing for the custom of shoppers.

Visually, these shops would have seemed very different to the modern eye, and perhaps a little alarming. Before the advent of health and safety, food would be left on display in the open, often susceptible to flies and the dust from the street; food handling was not subject to any kind of control and it is doubtful whether the busy shopkeepers had time to wash their hands particularly often, as customers expected to be served from behind the counter rather than to pick up their shopping themselves. Shops were advertised from the high street by big signs, often giving a rather cluttered appearance; brightly coloured awnings also attracted attention. It was not until later in the Victorian era that shop displays started to change to reflect the lifestyles of their customers, with prices being displayed on goods. Before this, the customer would have had to ask the price, which may well have been subject to change!

Due to this need to communicate with shopkeepers, who would wrap items individually and weigh out orders, shopping was also a far more sociable affair. In a village, shoppers might expect to see the same faces every day, and this made stores

such as grocers' very much at the centre of a community. This is in marked contrast to the present day, where customers pass through in such great numbers and at such a speed that a visit to the local Tesco Metro is far from a social occasion.

It was undoubtedly the supermarket that heralded the demise of the grocer, baker and butcher on Britain's high streets. Supermarkets operating on the high streets could offer cheaper prices and a faster, more convenient self-service shopping experience. Local or regional chains became national companies buying in bulk, now able to transport goods across the country; their success was assured. By the 1960s, self-service supermarkets dominated and there was no longer a need to visit the high street every day. Gradually, the focus was taken away from the high street and towards bigger, out-of-town stores, built conveniently near to residential areas in the rapidly expanding suburban areas.

Clothing was another high street staple, attracting a wide variety of skilled merchants and manufacturers. Dressmakers, tailors, bootmakers, milliners and haberdashers all competed for the attention of men and women from all walks of life. Quite often theirs was a captive audience, as many women would not have been able to travel far from home in order to clothe themselves and their families; poorer families would have relied on mending old clothes rather than buying new. However, for the wealthy elite the options were nearly limitless; private seamstresses could recreate the latest fashions and for men, proper tailoring was a mark of good breeding and success.

Some of these shops, of course, have now simply vanished from our high streets, and by the turn of the twentieth century were already seeing a drop in demand and significant loss of business. Blacksmiths were once assured of a steady trade, but the industrialisation of the world around them saw people turn to mass-produced, cheaper items rather than something locally crafted. Farriers, once in high demand due to our reliance on horses for transport, were forced out of business by the arrival of the motor car in all but a very few areas.

The growth of the department store from the mid-nineteenth century onwards would see a great change come to the British high street. Small shops bought up nearby vacant properties and expanded their ranges; the idea of shopping for pleasure rather than necessity was one that developed with the growth of the affluent middle classes, who had time to spend in a department store. Bright, visual displays drew the attention of the shopper, while in stores like Selfridges there were reading rooms, educational displays and technological advancements such as escalators. Originally, of course, these were confined to the biggest shopping areas such as London, but soon spread to smaller cities and large towns. This inevitably meant that local businesses were no longer able to compete with the lure of the big stores.

Internet shopping, in recent years, has been blamed to a large extent for the decline in independent shops on the high street. Bookshops have been unable to cope with the low prices and convenience of giants like Amazon, and larger chain stores have generally been the only ones able to weather the competition. Clothes shops have likewise struggled as shoppers have grown to prefer the reliability of recognised chain stores, all of which are priced competitively and provide a much wider selection than smaller shops.

This process of social and technological development has been a steady presence on our high streets, kick-started by the Industrial Revolution and still ongoing today. The changing nature of shopfronts and interiors is one manifestation of this change.

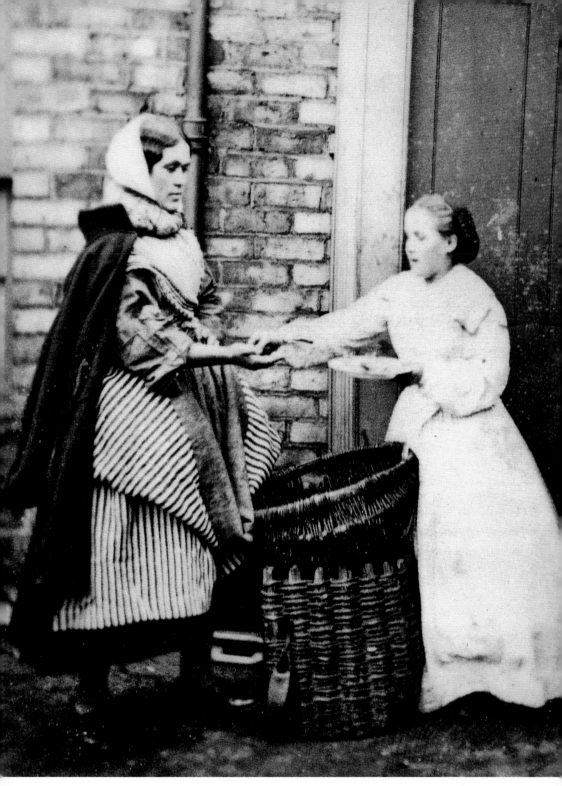

This traditionally garbed fishwife with her creel and basket was photographed in 1860 in Galashiels. The newly arrived railway allowed for the easy transport of fresh goods from the sea.

Right: Halifax's Crown Street in 1860 was full of overhanging timbered buildings. Shop fronts were very different to those seen today.

Below: A later image of Crown Street. Note the 'fancy draper' on the left; this gentlemen's outfitter seems to be doing well. By this point, there are far more awnings and signs advertising various shops.

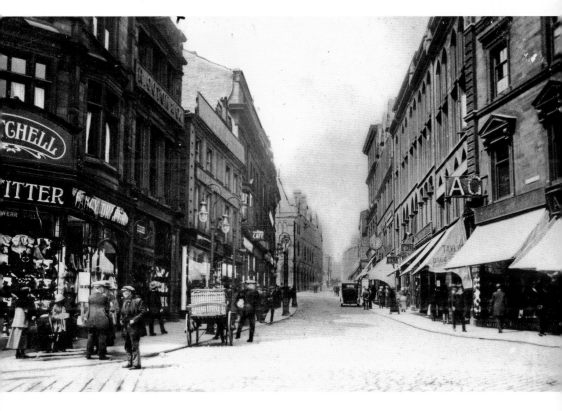

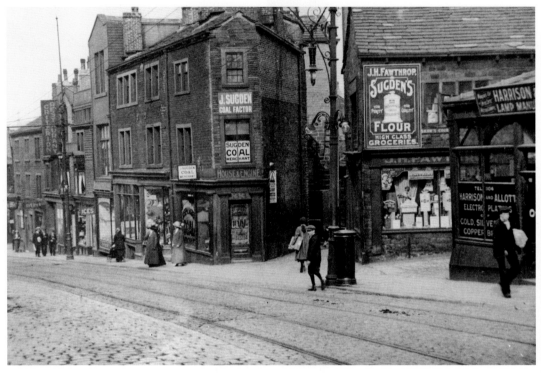

King Cross Street, Halifax. The coal merchant is well advertised – not a business that one would find on a modern high street.

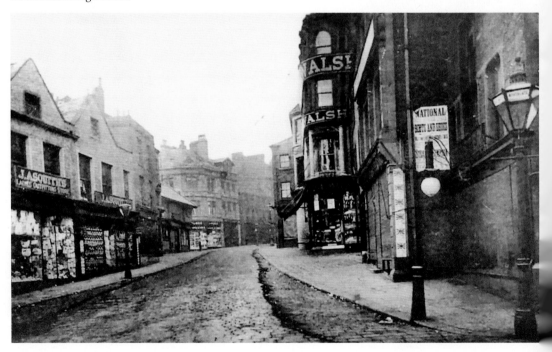

Old Market, Halifax. John Asquith, drapers', is no longer there; this has been replaced by an arcade.

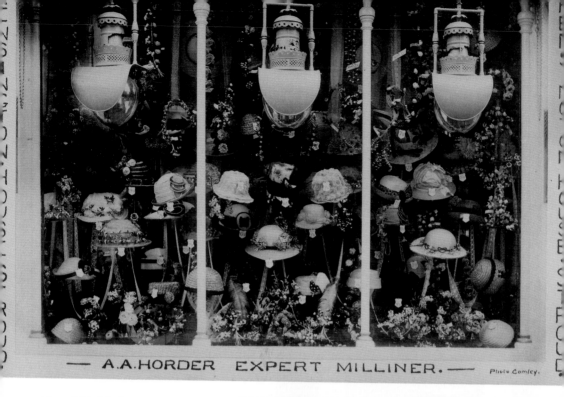

— A.A.HORDER EXPERT MILLINER. — Photo Comley.

Above: This fabulous window display belongs to a millinery in Stroud, around 1910. With the change in fashions, this shop would have no longer served a purpose; today the premises belong to a Millet's hardware store.

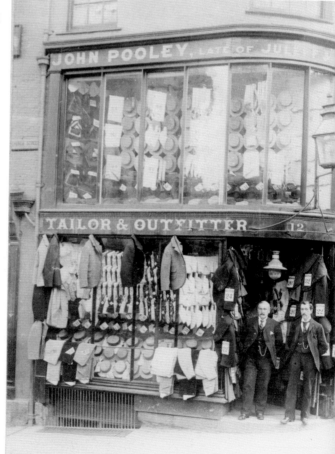

Right: A tailor's shop window in St Austell, 1885. Coats and trousers hang outside, while smaller items are displayed indoors.

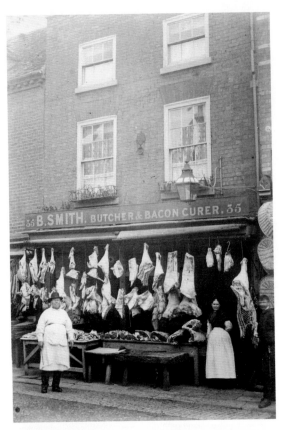

Left: A Worcester butcher's shop in the Shambles, 1886. There were eighteen butchers' listed in the Shambles in the late 1800s, testimony to the great demand for fresh meat; now, of course, butchers struggle to compete with supermarkets.

Below: The same shop (though run under a different name) can be seen on the right of the image, and the opposite pub is fittingly called the Butchers Arms.

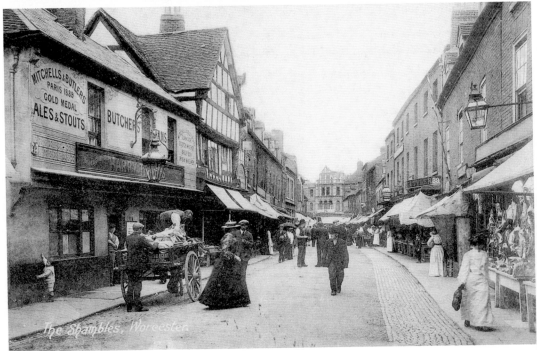

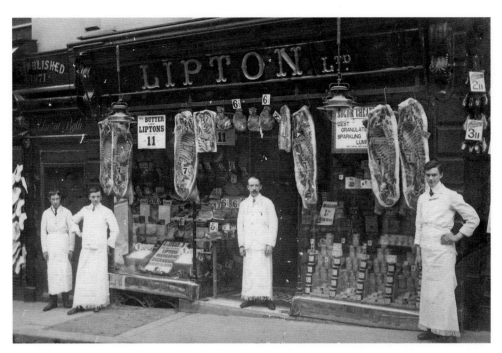

Above: A Lipton's grocery store in Stroud, around 1911. *Below*: A distant but familiar Lipton's in Galashiels in around 1930. This early group is no longer with us as a grocer, but it certainly proved an early factor in the demise of independent stores. Note the meat hanging outside in the earlier image – health and safety inspections had not yet come into being.

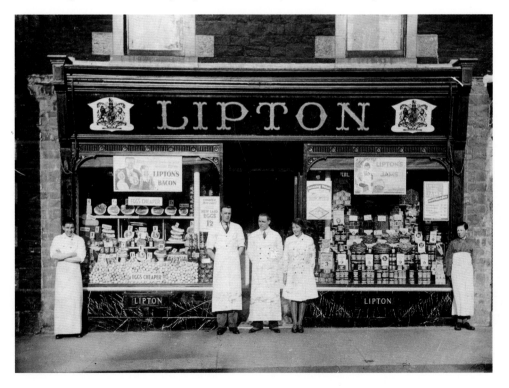

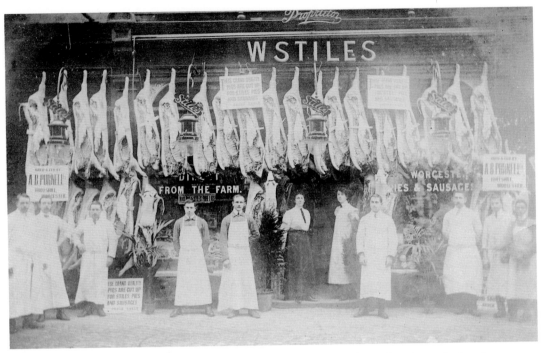

Above: Yet another Worcestershire butcher (this one very well-stocked!). *Below*: An agricultural supplier's. Again, this is not a shop that one would find on today's high street, but before the decline in agriculture this would have been well frequented by farmers and landowners, who would come to town to trade and do business.

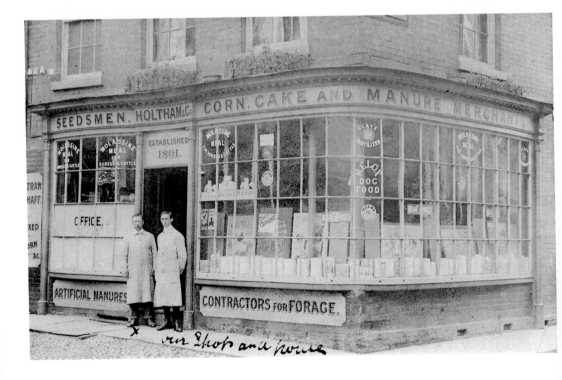

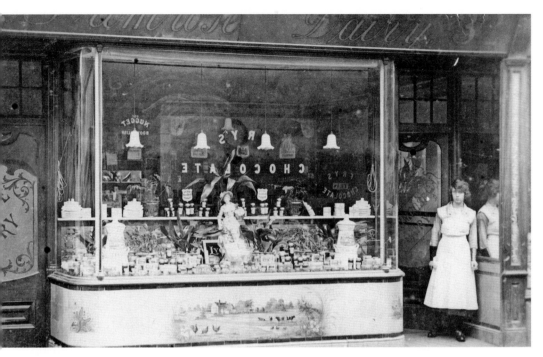

This dairy in Maidstone is also a vanished sight from the high street. Photographed in 1910, the store features an elaborately painted shop front to entice customers.

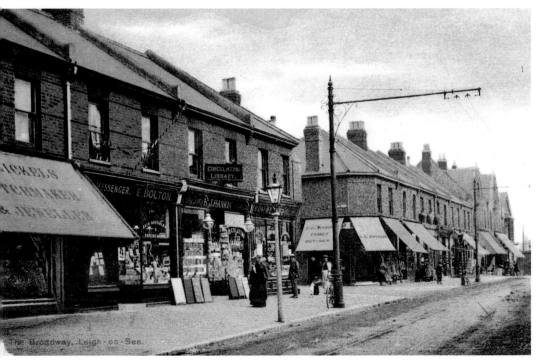

A view of Leigh-on-Sea's High Street, showing matching awnings up and down the street. A butcher, a circulating library and a jeweller can all clearly be seen.

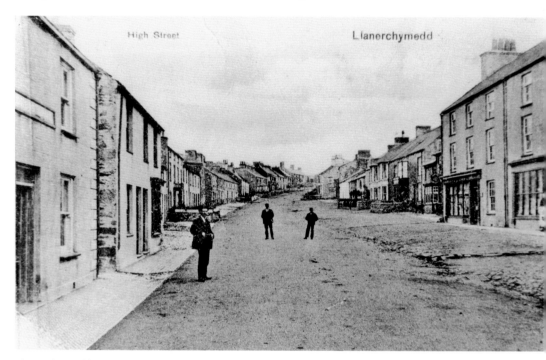

Llanerchymedd High Street, on the island of Anglesey, seems rather less affluent. A decline in trade for local shoemakers, of which there were some 250 in the nineteenth century, has left a rather desolate-looking high street.

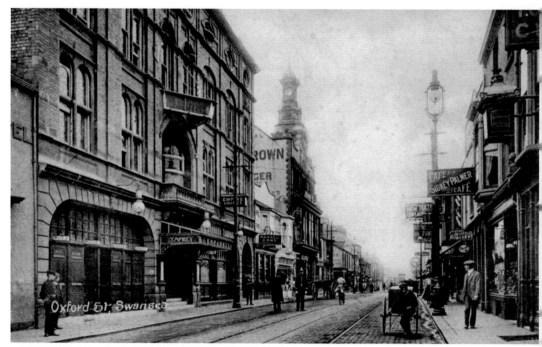

Swansea's Oxford Street, around 1905. On the right side of the road can be seen signs for a café, a skittle alley and 'new teeth'.

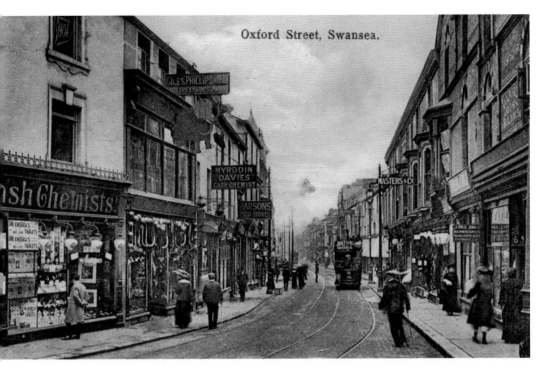

This slightly later image of the same street in Swansea shows a 1913 Boots the Chemist, as well as numerous other long-gone stores.

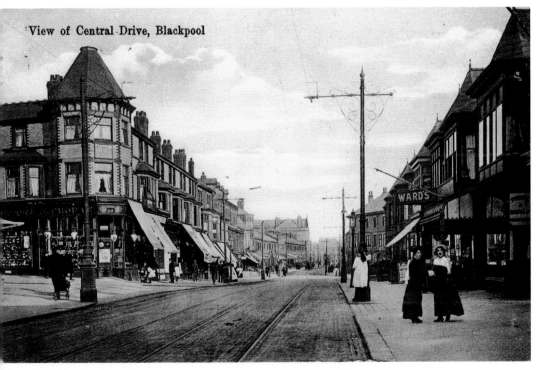

This is an early twentieth-century view of Blackpool's Central Drive.

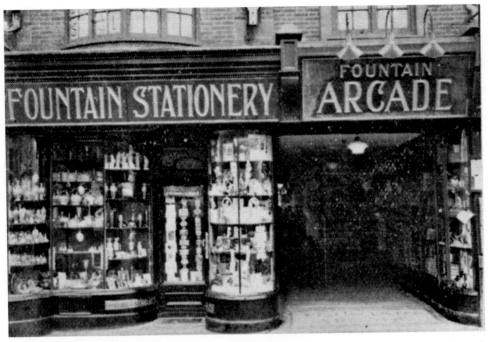

The Fountain Arcade, Dudley, taken from a 1929 guidebook. This is still in situ today, although presumably the shops have changed.

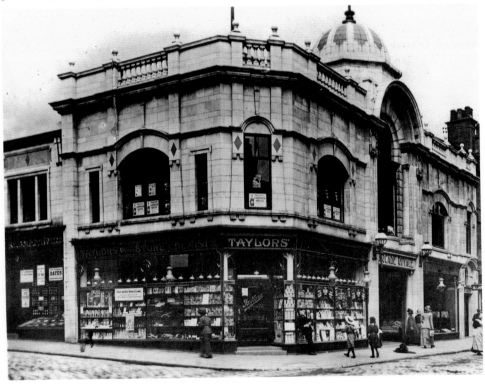

The entrance to the Arcade Royal in Halifax, opened in 1912.

Two views of Dudley Market Place. The two images show the same fountain. The curve in the market stalls is said to be due to the course of a spring flowing through the market.

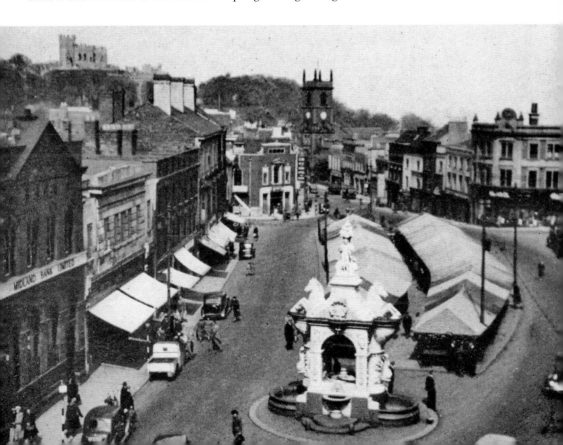

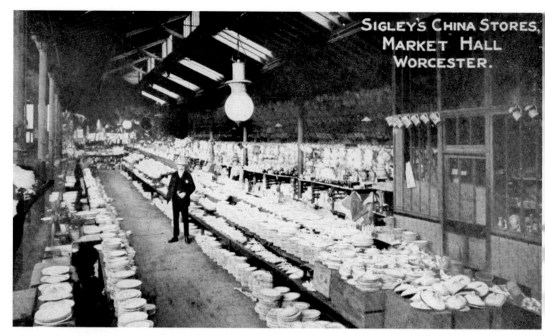

A bewildering array of china in Worcester's Market Hall. Sigley's China Stores was also based in the High Street, but presumably the famous Worcester pottery sold well enough for them to expand onto other premises.

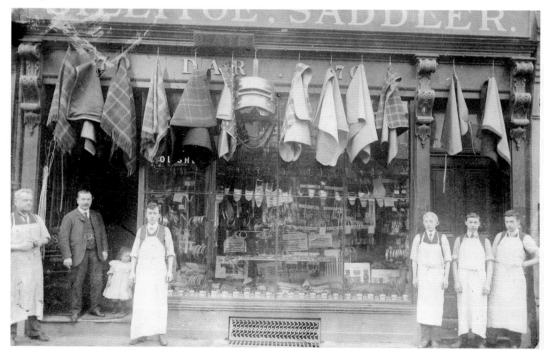

Saddlers were once a common sight, but as horse ownership has become less common so they have disappeared from the streets. This 1906 Worcester image shows a shop stocked with every kind of riding equipment.

Both of these postcards show images from London's many markets. *Above*: Holborn's Leather Lane Market in around 1906 (a poverty-stricken area). *Below*: A market porter from Smithfield Market.

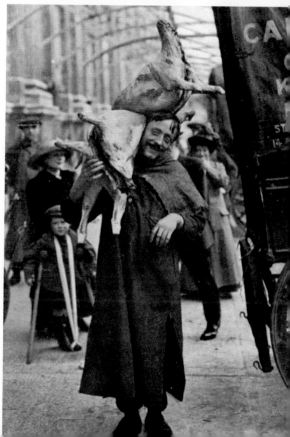

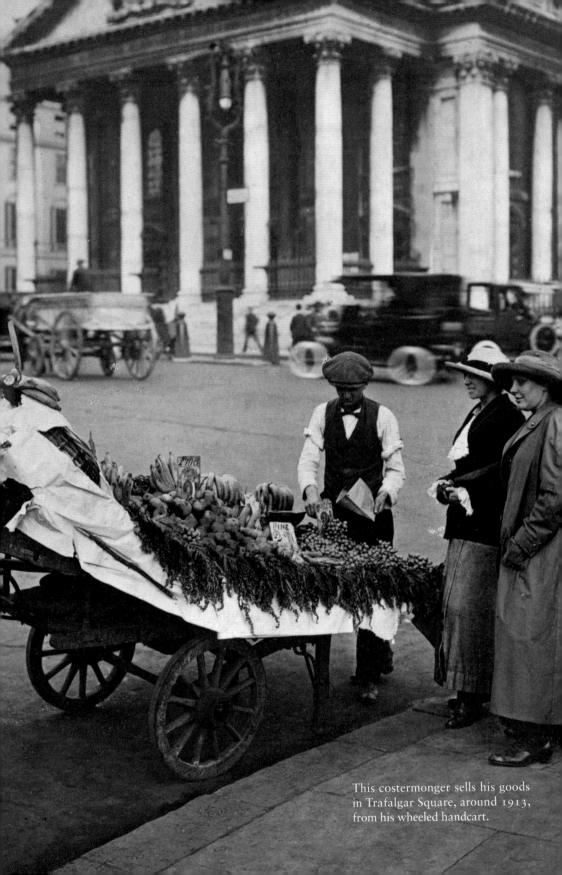

This costermonger sells his goods
in Trafalgar Square, around 1913,
from his wheeled handcart.

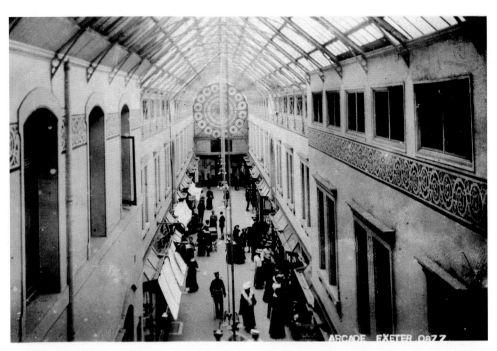

Two images from Exeter. *Above*: The East Gate Arcade in around 1909. This elegant building was sadly destroyed in the Blitz. *Below*: Colson & Co. in the High Street, around 1935. This is now a House of Fraser, having undergone several name changes and been rebuilt in the 1950s.

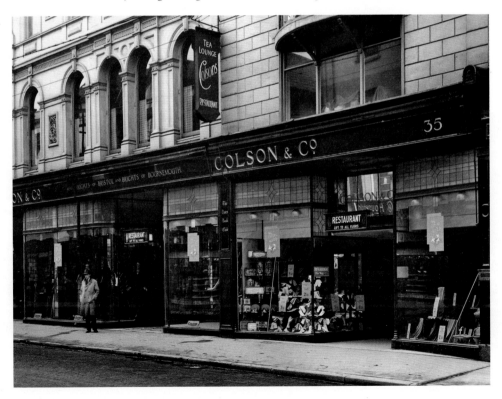

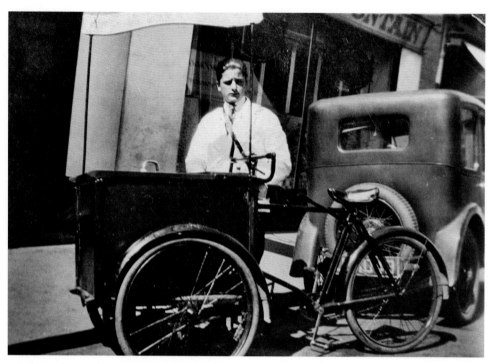

Street vendors often took a more unusual form, such as this ice cream tricycle from the late 1930s. This is still a family business today, although the tricycle has had an upgrade.

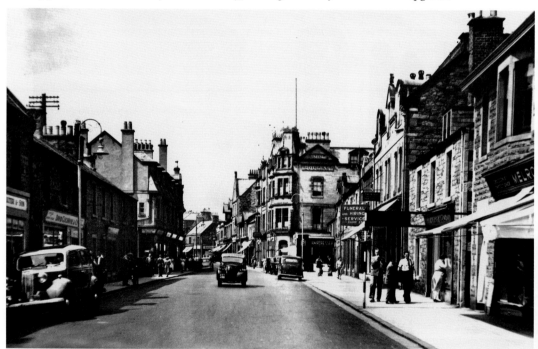

Galashiels' Channel Street, featuring a diverse range of signs advertising everythingfrom funeral services to hairdressers.

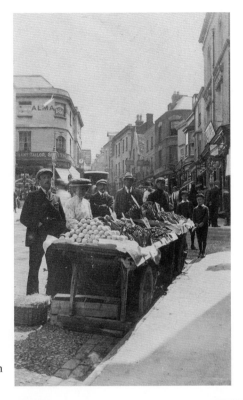

Right: A fruit and vegetable seller's stall on the corner of Stroud's High Street and Kendrick Street. *Below*: An image of the busy High Street. The signs are wildly varied, again, advertising everything from stationers to coke and coal suppliers.

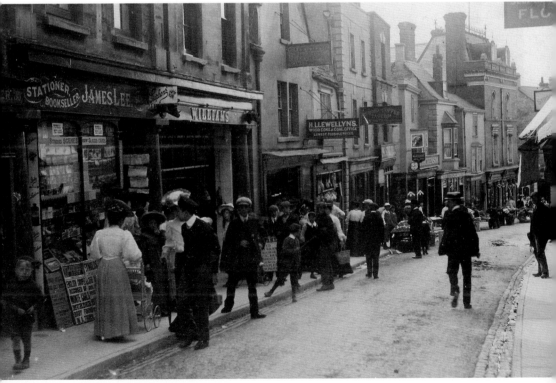

Left: The Durham City Dairy Company, also advertising its upstairs tearooms.

Below: Looking up Silver Street. Another Lipton's grocery is just visible.

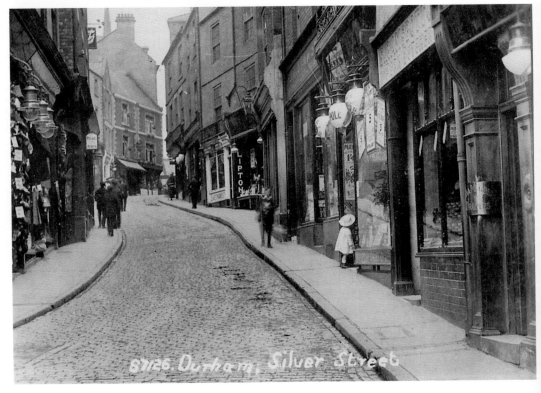

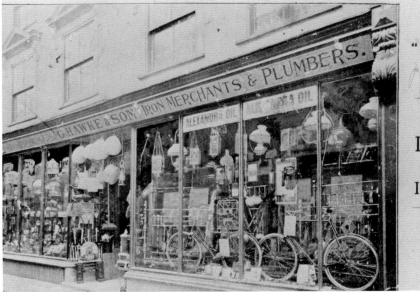

A business card for George Hawke & Son, St Austell and Fowey. Business was clearly booming for this store, as their very full shopfront indicates.

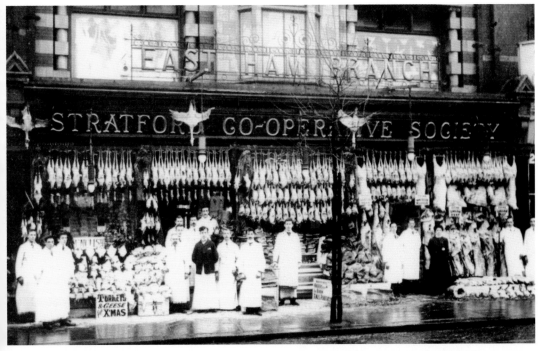

A large Co-Op in East Ham, again with a full window display, advertising turkeys and geese for the Christmas period.

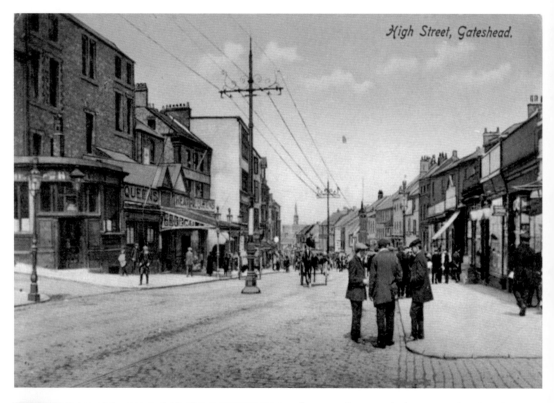

Above: Looking north down Gateshead High Street. All of the buildings in this image are long gone.

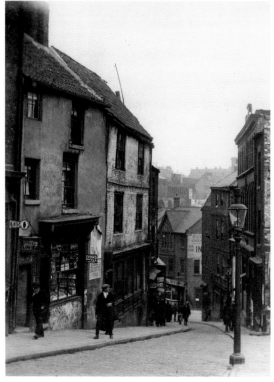

Left: A view from Bottle Bank, Gateshead, down towards Bridge Street. This was at the time the commercial and industrial heart of the town, but most of these buildings were destroyed in 1930.

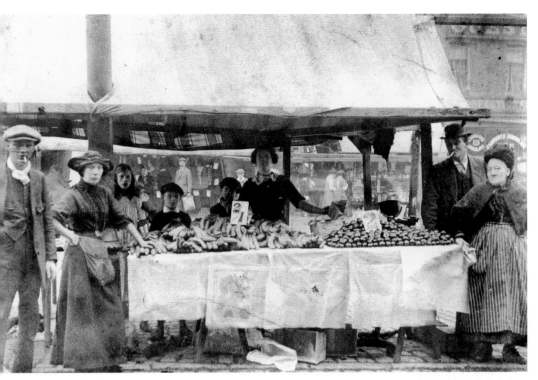

A Dudley market stall.

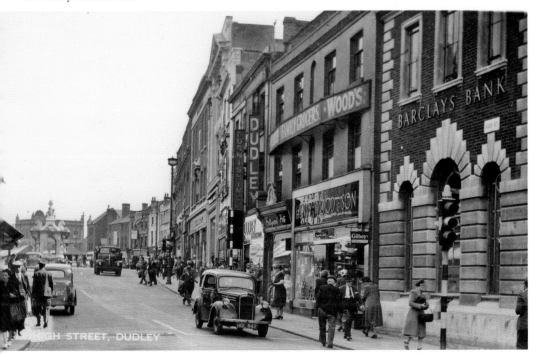

A later image of Dudley's High Street, but still showing a far greater number of independent stores than one would find today, including Wood's grocer, Hollywood Hats and Dudley's furnishing stores.

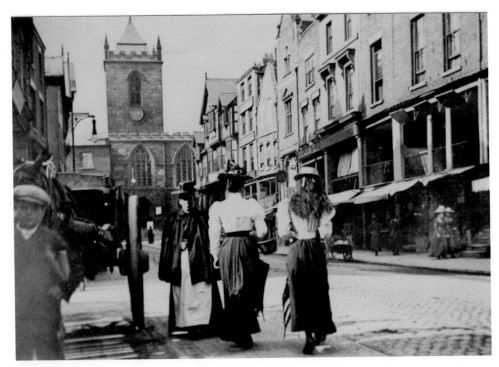

Chester's Bridge Street, 1890. This is still a busy shopping area today, though the average shopper is probably less well dressed than these Victorian ladies.

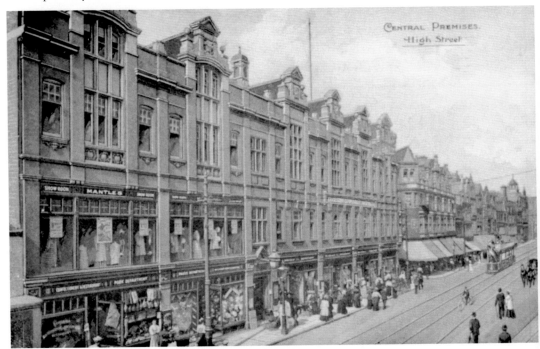

The Co-Op in Leicester's High Street, a large and popular department store. It was opened in 1894, and is now part of a shopping centre.

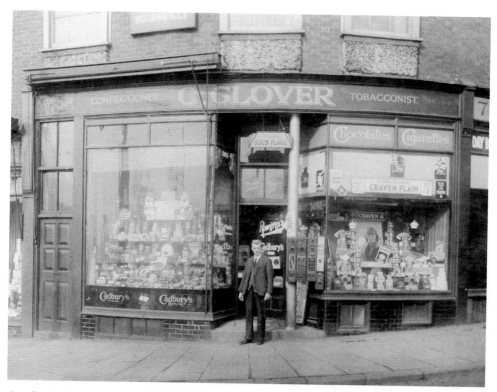

Another Leicester store, Glover's in Applegate Street. This long-vanished shop advertises a wide variety of confectionery; well-known brands like Cadbury's were as popular then as they are today.

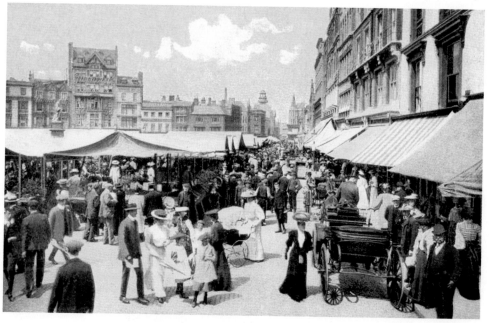

Leicester's Market Place. A market has been held here for at least 700 years and, as can be seen from this view, it was popular with traders and shoppers alike.

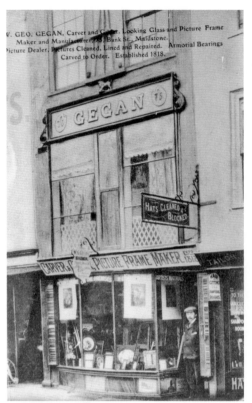

Left: An advertisement for Gegan's Picture Framers in Maidstone, around 1900. Framing pictures as well as cleaning and restoring pictures for Maidstone's larger households would have been a lucrative business; as the advert suggests, he was also a carver and gilder.

Below: In the 1970s, these two shops in Maidstone were very popular with collectors and represent a vanished pre-eBay age.

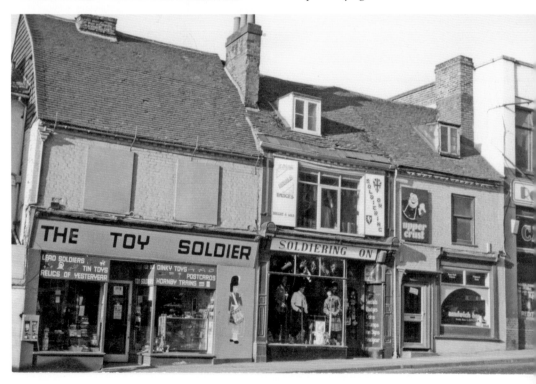

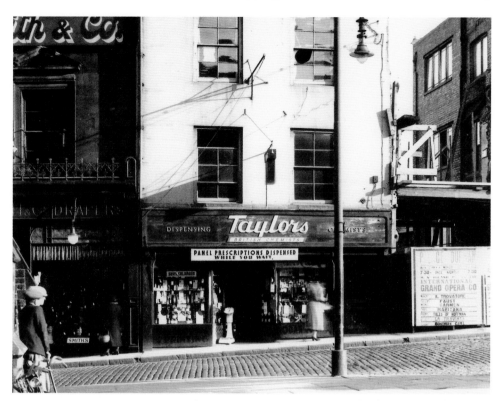

Taylor's the chemist, in Durham's Market Place. This image from 1938 also shows a billboard for the theatre.

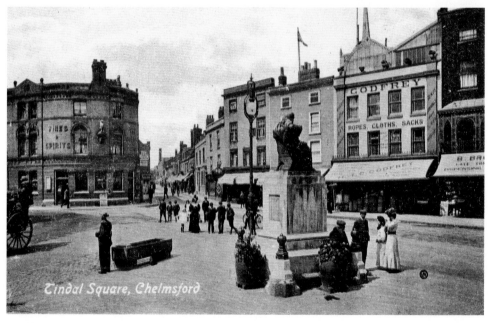

Godfrey's advertises 'Ropes, Cloths, Sacks' in Chelmsford's Tindal Square. The statue of Tindal still stands, though Godfrey's has gone.

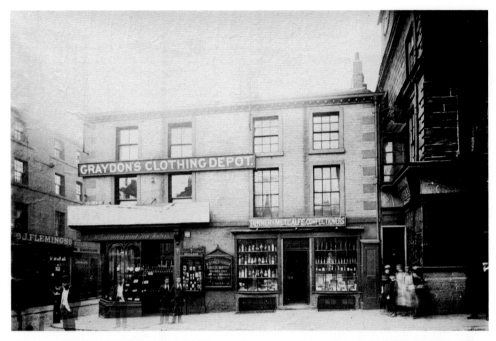

Graydon's Clothing Depot in 1880s Halifax, on the corner of Crown Street and Corn Market. There is a sweet shop next door, in turn handily located next to a sign advertising the services of a local dentist. Today, a gentlemen's clothing store still occupies this spot, though the name has changed.

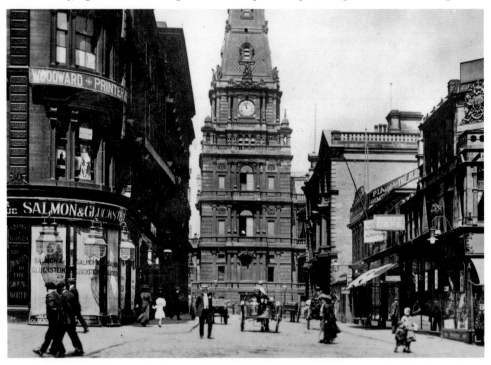

Princess Street in Halifax, also showing some very different shopfronts. A music warehouse can be seen on the right.

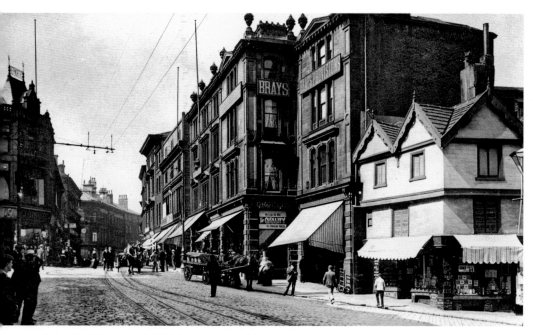

Northgate and the top of Woolshops; this Halifax scene is still recognisable today, especially from the 'Tudor House' to the right of the image, which has since been restored. The grocery shop has gone, and Hays Provisions is now a bank.

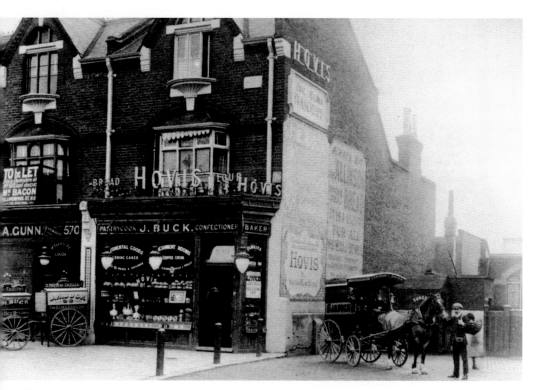

This bakery in Leytonstone's High Road is definitely proud of its Hovis connections.

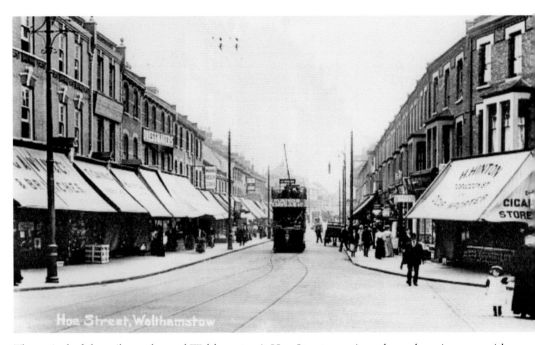

The arrival of the railway changed Walthamstow's Hoe Street, creating a busy shopping area with a lot more residents.

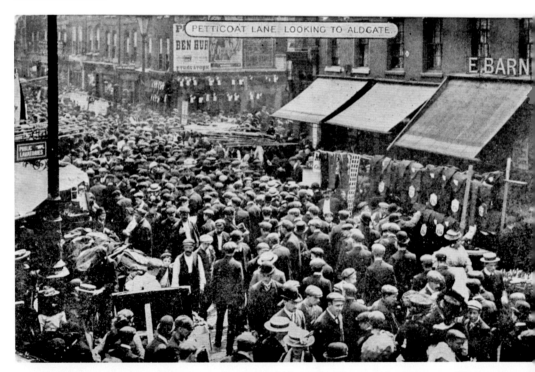

To call this Petticoat Lane market scene 'busy' would be a significant understatement. The market, which dates from medieval times, was held in a district famous for the manufacture of clothing in the eighteenth century.

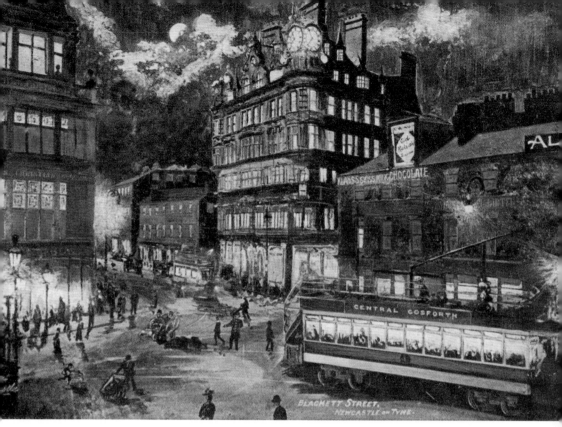

Above: A postcard depicting Newcastle's Monument area in the early twentieth century. Shops are brightly lit and customers are many, indicating a thriving shopping area. *Below*: A 1905 image of Blackett Street shows that this has not been exaggerated.

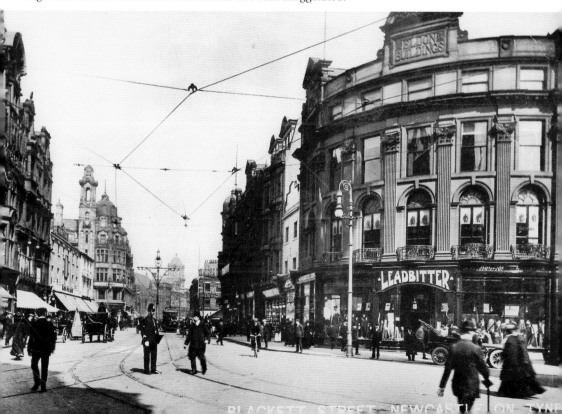

Blackpool in 1920. This view of Chapel Street shows a bustling scene, along with a good selection of shops. This was demolished in the 1960s in order to widen the road.

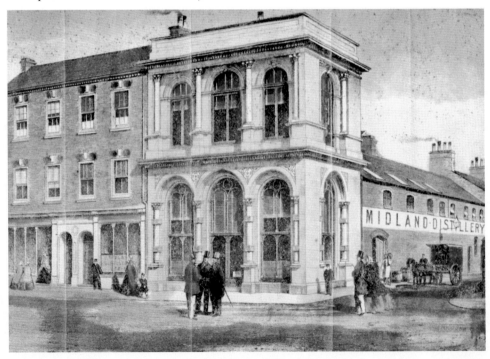

A wine and spirits warehouse in Leicester. The Midland Distillery has been replaced, but the building was recently refurbished and remains.

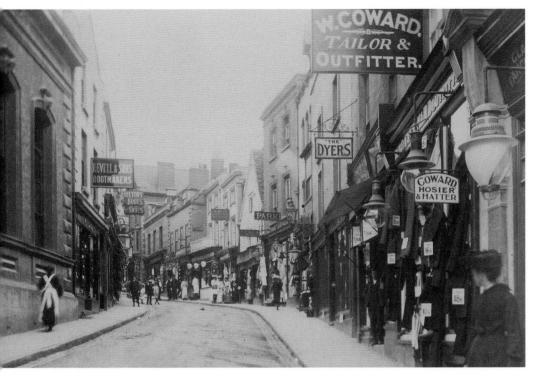

More scenes from Stroud's busy High Street. *Above*: In this earlier image, the shopfronts all have goods hanging outside – clearly this was a more trusting age. *Below*: In this later image, fewer goods have been left outside for customers to browse.

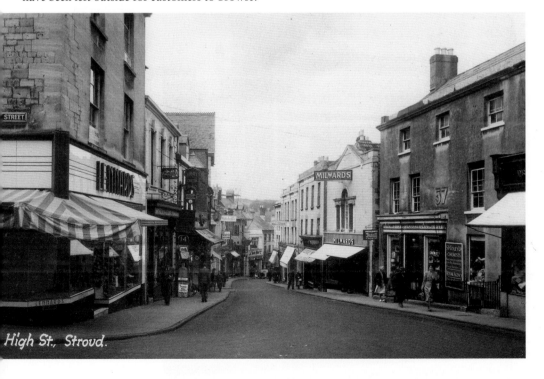

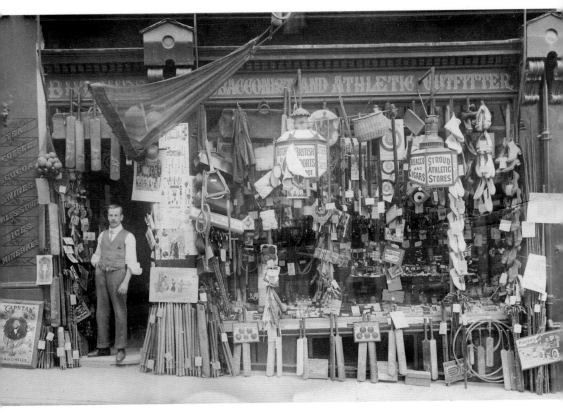

Above: Sports shops on the high street are still a common sight, and Stroud's Athletic Stores a century ago would be a familiar sight to the modern shopper, though the sports equipment displayed might have changed somewhat.

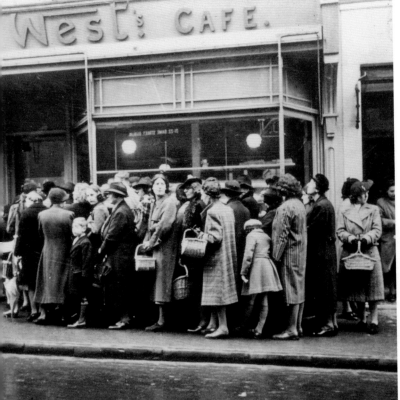

Left: A bread queue outside a café in Stroud is a reminder of the way shopping habits were forced to change during the Second World War.

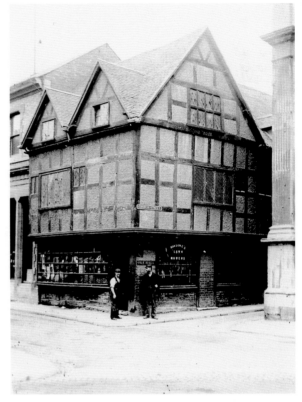

Right: A late Victorian photograph showing Hall's Ironmongers in Worcester's Shambles. The building, constructed around 1600, was unfortunately demolished in the 1960s.

Below: In 1920, a watchmaker, butcher, grocer and boot repairer occupied this stretch of road in Barbourne, Worcester.

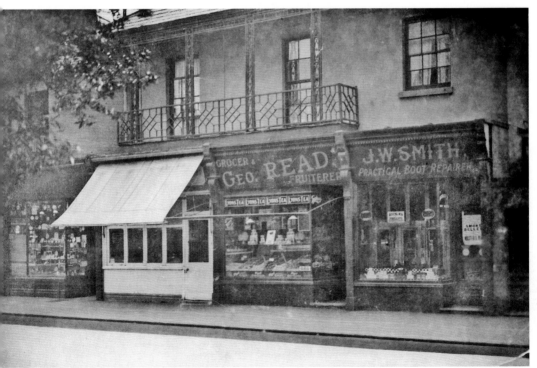

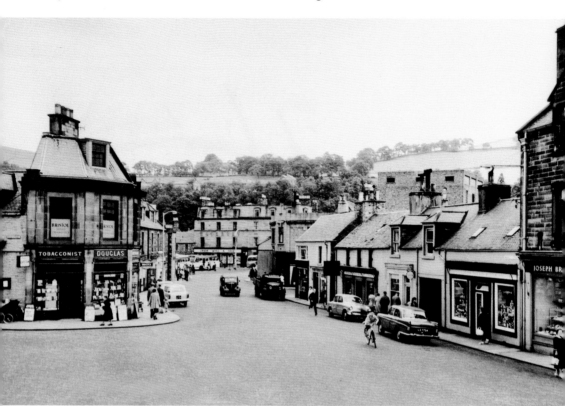

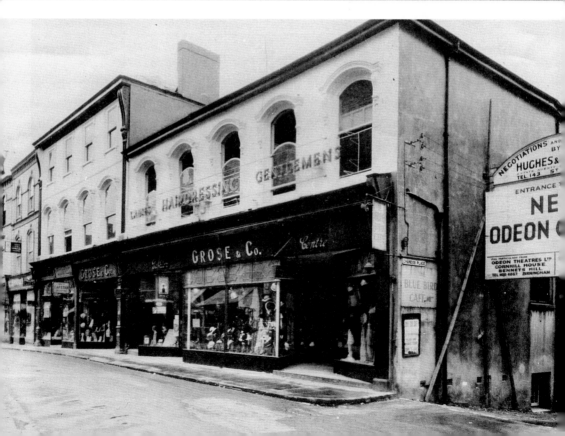

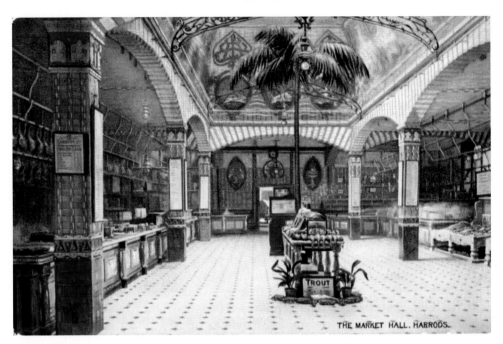

THE MARKET HALL, HARRODS.

Above: Harrods department store, London, in around 1906. This is the food hall, and the postcard showcases the Doulton tiling in the Brompton Road store, many years after Charles Henry Harrod set up his grocery shop in 1848.

Top left: Channel Street and the Market Square in 1950s Galashiels. Larger shops predominate and goods are no longer displayed outside.

Bottom left: Well-filled shopfronts in St Austell, alongside an advertisement for the new Odeon cinema in 1935, which was to open in 1936.

LIFE ON THE HIGH STREET

The high streets of Britain fulfil many purposes. Far more than being just a collection of shops, they are often the hub of the local community and provide multiple services, as well as a meeting place, offering a natural point for people to gather and socialise.

The look of the British high street has changed dramatically over the years. Some towns that originally had just a cluster of shops now play host to an incredibly varied array of stores and shoppers, while for some towns, their high streets have been demolished, built upon, bulldozed through – 'lost' in a very real sense. For some towns their very identity may have changed, whether with the rise and fall of industry, the coming of the railways or simply through the changing needs of the inhabitants; all this has seen life on the high street vary tremendously over the last 200 years.

Where there are shops, there have always been places for the weary shopper to rest – sometimes just a stone bench, but in most towns a hundred years ago there would also have been an inn, or even a coffee house. Inns were, of course, primarily aimed at the traveller; it would be some time before eating out became attainable for the masses, and a long while before the dawn of the 'gastropub'. The rise of the middle classes contributed to this; with more money to spend, dining in public became a great way to see – and, more importantly, be seen by – other members of local society. Gentlemen's clubs and coffee houses provided a resting place and often other entertainments as well. Hotels were frequently grand and expansive, a not-particularly-subtle hint at the prosperity of the town to the unwitting traveller.

Other buildings jostled for space alongside coaching inns and grocers' shops, fulfilling the spiritual and social needs of the community. The high street would often be the setting for one or more churches, especially as growing populations demanded grander and more central (as well as more numerous) places of worship, often dominating the high street with grandiose, imposing architecture. Many of these remain today, and are often the only surviving architectural reminders of a bygone era. Town halls and other public buildings were also common sights, though many of these have now been turned into museums or simply used to create more shop space. Local councils also built monuments – few towns today are without a war memorial – drinking fountains, town clocks and great market spaces; all of these were crammed on to the high streets, ensuring that they were at the very centre of the daily life of the inhabitants. Many of these remain today as representations of a town or city's historic past, and in this way they have to a great extent fulfilled their original purpose; we still use them as meeting places, decorate them and photograph them.

Of course, it wasn't all about shopping and town pomp. Theatres were always popular, whether grand opera houses or small halls where local productions could be put on for a low admission fee. They were usually lavish, ornate buildings, a good way of raising the profile of a town as well as enticing people in for the evening. In an age before television or radio, a new production at the theatre was a breath of fresh air. Actors, singers and dancers were celebrities then as they are now and people would flock to see a new production.

With the invention of the cinema, many theatres were converted, or new buildings were constructed to meet the demand for this new form of entertainment. Not only did the cinema provide the entertainment of a film, it also included a newsreel; during the first half of the twentieth century, this was a vital way for cinemagoers to stay up-to-date with current affairs, and until the introduction of the television into British homes it was the only way for them to view the news. Watching real events unfold on a screen was often a far more immediate and exciting experience than reading a newspaper. This importance meant that many cinemas took pride of place on the high street, or at the very least were advertised extensively; billboards, public transport, handbills and word of mouth all played a part.

As well as places for people to visit and be entertained, there was also the great possibility of the high street itself as a space that could be used for various functions. Situated in the middle of town, it was the natural focal point for the inhabitants, and this is shown by the sheer variety of uses that residents could find for the space. Street markets were common, often a weekly occurrence; many high streets were built wide for the purpose and still see use today for the very same markets that have endured for centuries. Yearly carnivals would parade through the high street. Public holidays – a coronation, a birthday, even Christmas – would roll around and shops would be highly decorated for the occasion, a tradition that has endured today.

The busier nature of our roads today means that now we are often confined only to the pavements on our high streets. Some of the scenes pictured would be impossible to recreate on our busy highways, such as shoppers strolling at their leisure across the road, only having to worry about dodging the occasional cart. The day is long past when young children could safely wander unsupervised across the road to the sweet shop, or when a farmer could drive a flock of sheep or a herd of cows down the high street – a feat which would be logistically impossible in heavy town traffic! Our busier, faster-paced lives have come at a cost, although increasingly in recent years town centres have been reclaiming the space for people, banning cars altogether.

The ways in which life has changed on the high street have influenced the high street itself, from developements in architecture to the very way we use the spaces around us. Gone are the days when water troughs for horses were necessary; in their place we see rows of parking meters and busy highways where once there were communities now long-lost. Such changes are often considered to be the hallmarks of our modern age of progress. The truth, though, is that just as we are driven by the need for buildings to be bigger, for roads to be better, for new entertainment to eclipse whatever came before, so too were our Victorian predecessors.

We might mourn for a golden age – one rendered misty and rose-tinted with hindsight – but we cannot escape the fact that the hunger for change, in that golden age, had already long since begun.

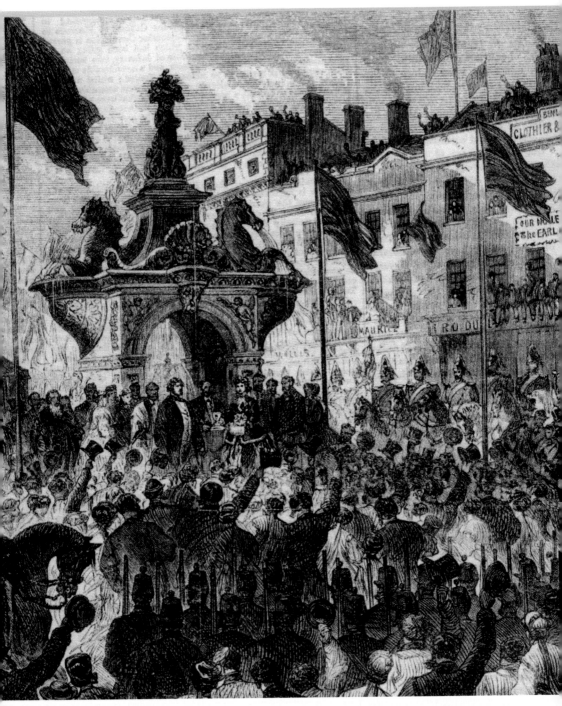

An 1867 illustration from the *Illustrated London News* showing the opening of a new drinking fountain in Dudley's Market Place. This grand occasion seems to have attracted quite a crowd; the fountain was intended to 'encourage temperance' in the town. Today, although no longer a fountain, it is still a distinct feature of the town, as shown in the image at the top of the opposite page, taken around a hundred years later.

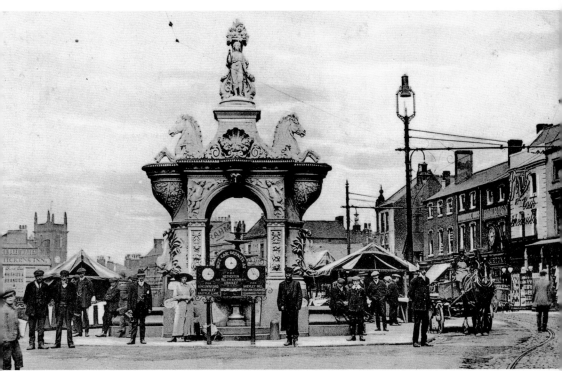

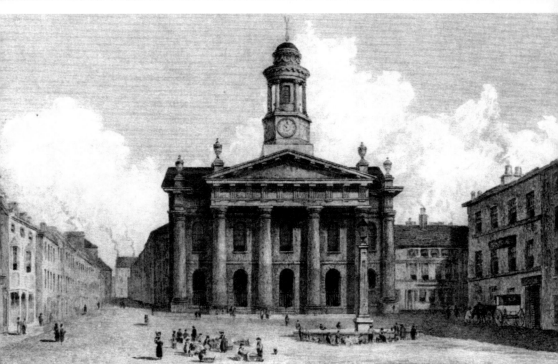

Above: Market Square, Lancaster. The imposing City Museum is pictured here in 1828. This was originally the town hall, built in 1781/2.

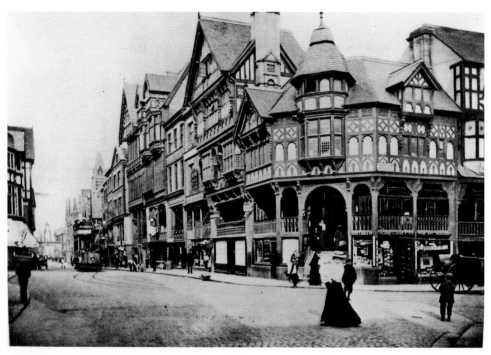

The elaborate and iconic building on the corner of Chester's Bridge Street. This was designed by Thomas Lockwood and actually built in 1888.

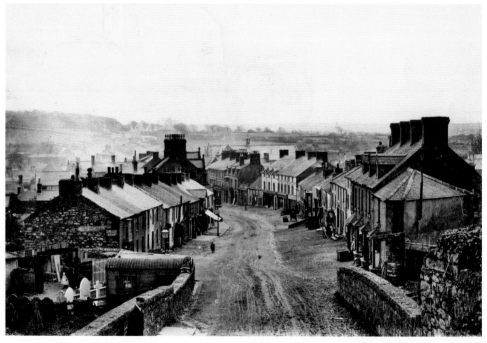

A very different scene in Llangefni High Street in the late 1880s, looking down from the railway bridge. The street itself is still unpaved, and although the roof of the recently built town hall can be seen in the distance there are fewer signs of progress.

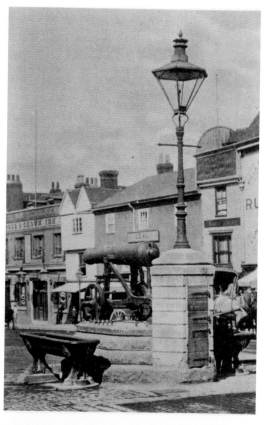

Two unique structures on Maidstone's High Street. *Right*: The Russian Gun, known locally as the Cannon; this is 1900, and there are still water troughs for horses. To the left of this picture can also be seen the Rose and Crown coaching inn, which closed in 1970. *Below*: An image of Astley House, erected in 1587. Although an attempt was made to save the panels when the building was demolished in 1871, they were too fragile, and disintegrated before they could make it to a museum.

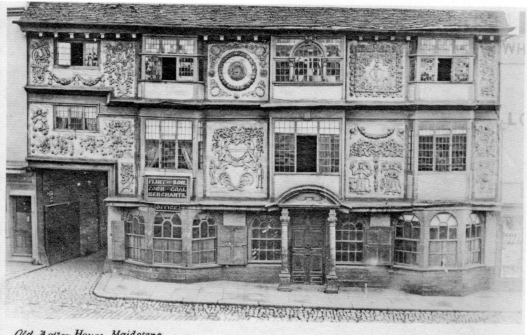

Old Astley House, Maidstone.

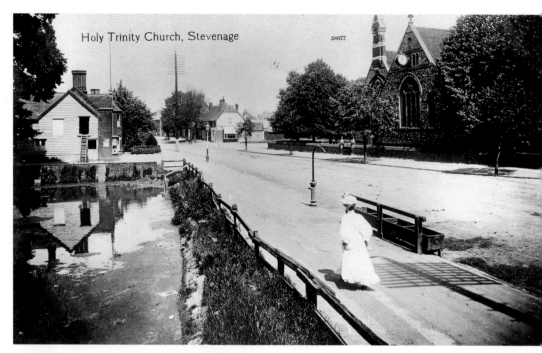

Holy Trinity Church, Stevenage

Above: At the bottom of Stevenage High Street, the rather murky Weir Pond lies on the left while the Holy Trinity church stands over the road. It was built in 1861. *Below*: This is a later view of the Methodist church, which was built in 1876; growing populations meant more churches were being built to cater to the needs of different denominations.

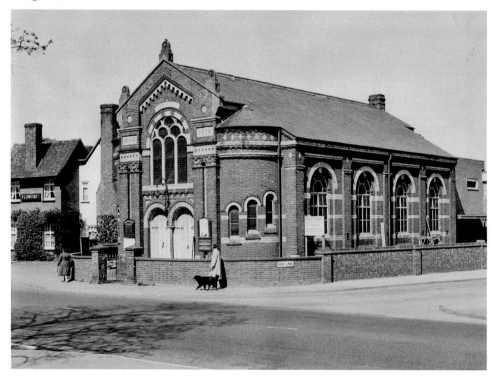

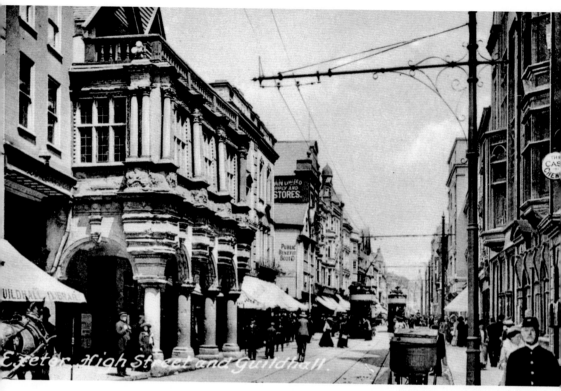

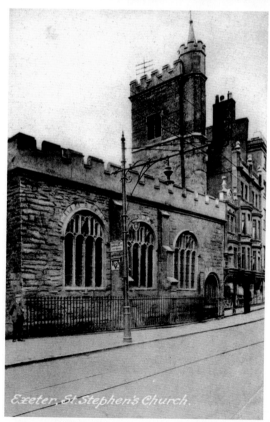

Above: Exeter's famous Guildhall in around 1910. This building has been in continuous use since 1160, and is still a focal point for mayoral functions and royal visits, among other things.

Right: St Stephen's church on Exeter's High Street. A church has stood here since at least the time of the Domesday Book, and the present church dates from 1664.

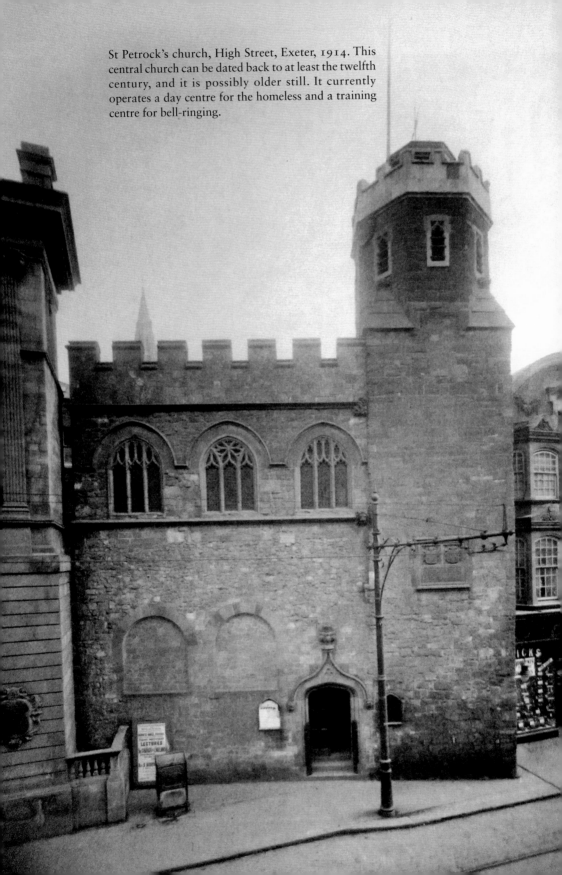

St Petrock's church, High Street, Exeter, 1914. This central church can be dated back to at least the twelfth century, and it is possibly older still. It currently operates a day centre for the homeless and a training centre for bell-ringing.

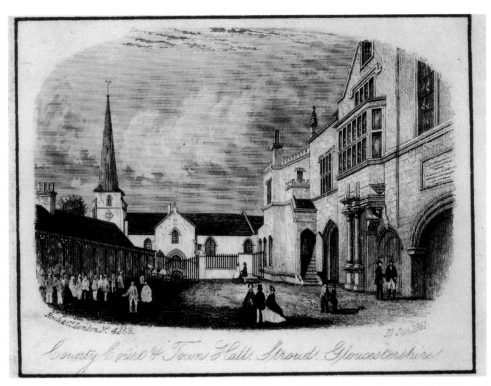

Above: This engraving from 1861 shows Stroud's town hall, as well as the old parish church, which was demolished in 1866. *Below*: An advert for Cornwall's first YMCA building, erected in 1893 in Victoria Square, St Austell; this building incorporated a gymnasium and a reading room. The building still stands, though the YMCA has moved elsewhere.

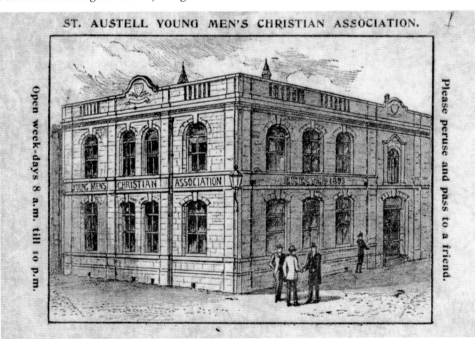

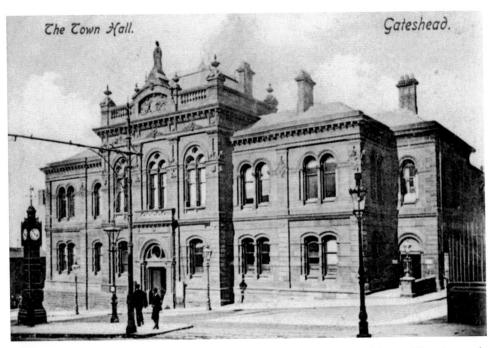

Above: The town hall, Gateshead. This was opened in 1868; a statue of Queen Victoria stands on the parapet.

Below: Looking south down West Street with the Town Hall still visible on the left. The clock tower was built in 1892.

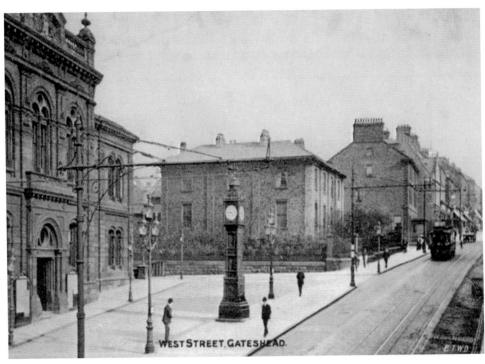

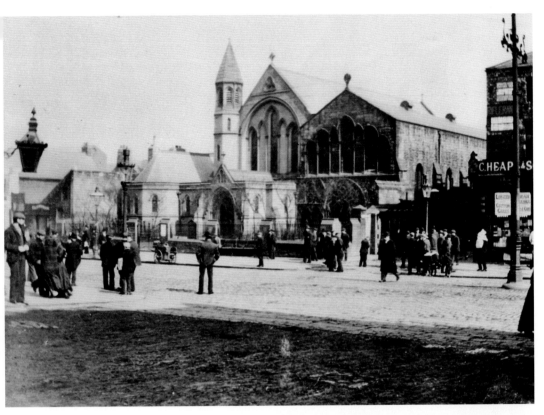

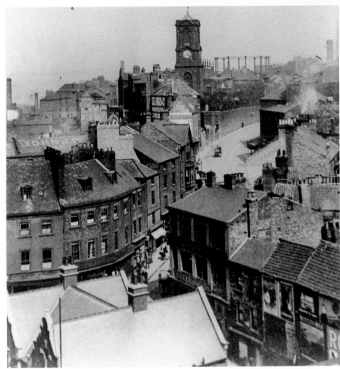

Above: Holy Trinity church on Gateshead's High Street, in around 1893. This church was built in 1836, incorporating the medieval St Edmund's Chapel, and still watches over High Street today.

Below: A view of vanished Gateshead; this is the area around St Mary's church, before the building of the Tyne Bridge. Most of this area was demolished in 1924, and St Mary's today is a lonely reminder of the busy streets that once stood here.

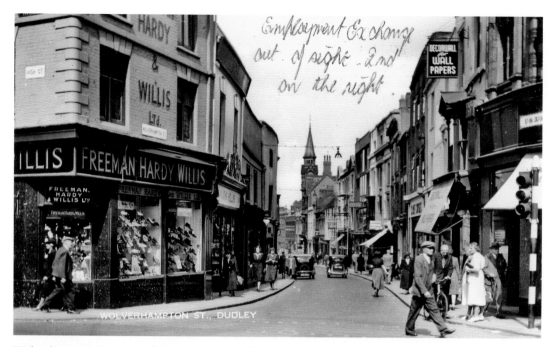

Wolverhampton Street, Dudley, in the 1940s. Although the image shows a bustling shopping scene, the note on the card is a reminder of the many other businesses and even government services that used the high street.

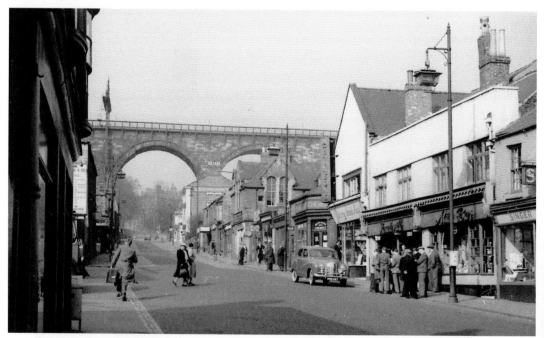

Durham's North Road in the 1950s. The cluster of people outside the Vaudeville Milk Bar shows the importance of this location as a meeting place; it was demolished in the 1960s, along with the other buildings.

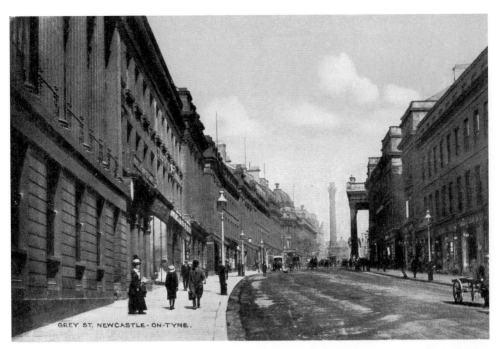

GREY ST, NEWCASTLE-ON-TYNE.

An early image of Newcastle's Grey Street, with Grey's Monument, dedicated to Charles Grey for the passing of the Great Reform Act of 1832, visible in the distance. The Georgian buildings are still in situ and little has changed. This street was in fact voted 'Best Street in the UK' by BBC Radio 4 listeners.

Pictured in 1909 is Galashiel's post office, built in 1896. The sign outside reads, 'Please do not spit'; hopefully this is not a reflection on the quality of the tea rooms on the left.

Left: The ancient Nag's Head on Highcross Street, Leicester, built in 1663 and demolished around 1875.

Below: An 1860 photograph of the Feathers Hotel in Chester; this once-famous coaching inn was demolished in 1863, but the buildings surrounding it have remained.

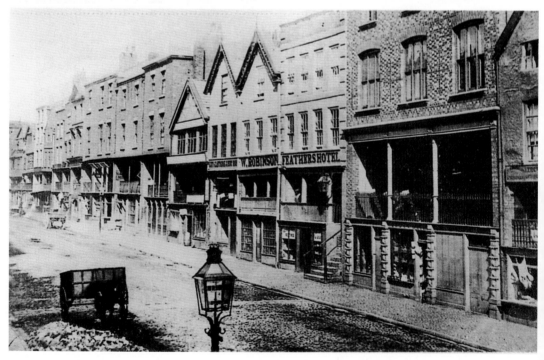

Webster's Café in Silver Street, Halifax. This grand café was opened in 1825; the building was demolished in 1963.

Above: The Yacht Inn, Chester, 1900. This coaching inn, once described as the 'premier hostelry in the city', served coaches travelling to London and Ireland. It was demolished in 1964.

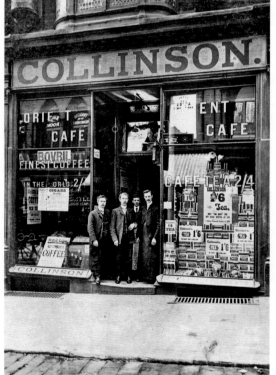

Left: Collinson's Cafe, Crown Street, Halifax. This tea and coffee merchant boasts the 'finest coffee in the world'.

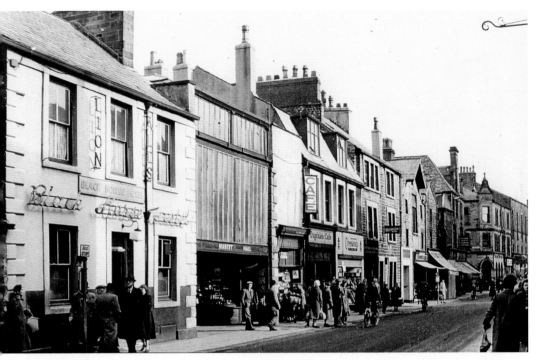

Above: The Black Horse Hotel, Lancaster, around 1950. A few doors down is a café. Neither the hotel nor the café has survived. *Below*: The Green Dragon pub in Stroud, which has fared slightly better, with the upper floors still remaining. The Greyhound Inn is now the Greyhound Café and Bar; the greyhound above the door, just to the left of the centre, has been preserved.

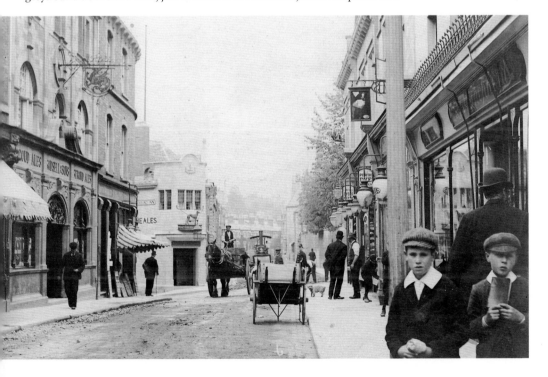

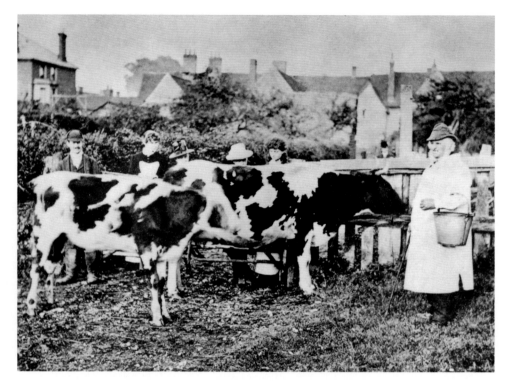

This scene behind the Red Lion pub in Stevenage is definitely one from another age; the landlord kept his cows in the field behind the pub, and is pictured here with onlookers in the late 1800s. Change is coming, however; the roof of J. Green's department store can be seen in the background.

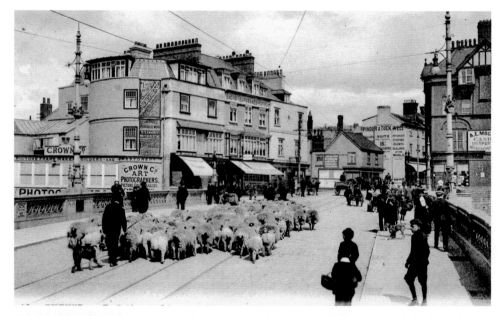

Driving sheep through town would be a daunting challenge in Exeter today! The excited dog on the right is an amusing contrast to the sober collie following behind the flock. Pictured around 1908, New Bridge Street was built to join Fore Street to the new bridge, which was built in 1778.

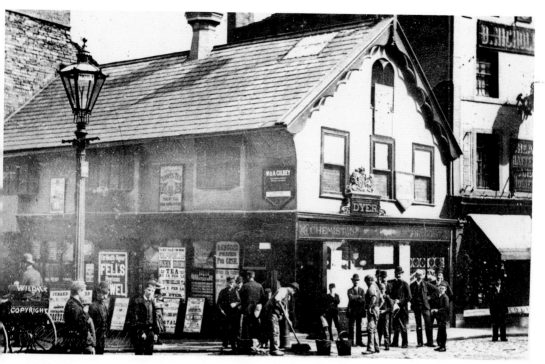

This building, known as the House at the Maypole, dates back to around 1500. At this point in time it was home to Dyer's the Chemist; in 1890, faced with demolition, it was rebuilt on Leeds Road.

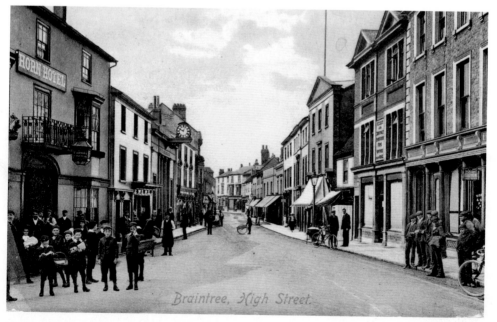

Little has changed on Braintree's High Street since this photograph was taken, although the Horn Hotel on the left has been replaced by shops. There are a lot of curious faces turned towards the photographer.

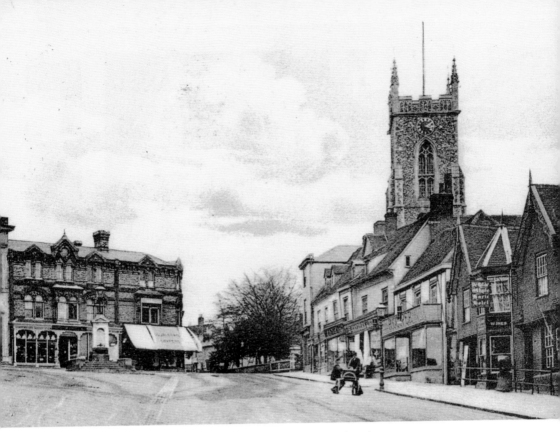

Above: Market Hill in Halstead, watched over by St Andrew's church.

Below: The junction of High Street and Island Street, Galashiels. The former Golden Lion pub stands unoccupied on the left.

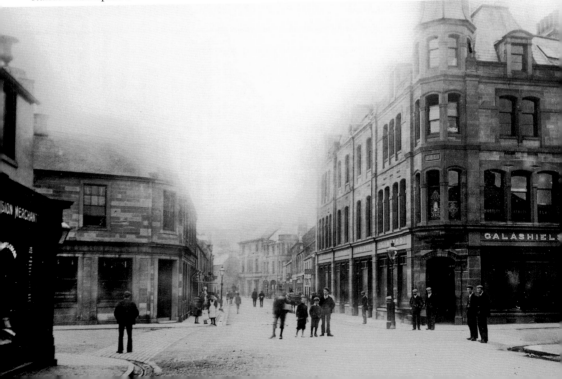

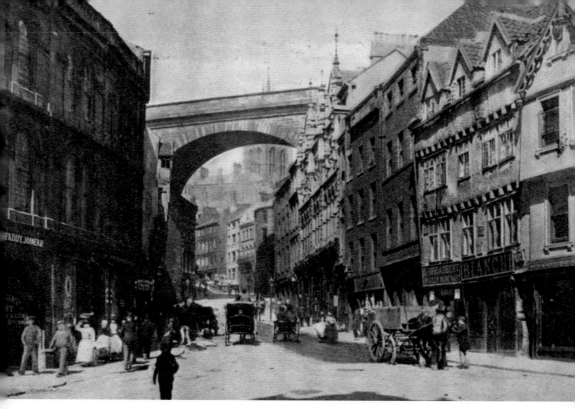

Above: The viaduct over Dean Street, Newcastle. Such features dramatically alter the look of the city; the church is hidden from view, unlike in the earlier image on page 9.

Below: Jubilee decorations on Newcastle's Northumberland Street, 1935.

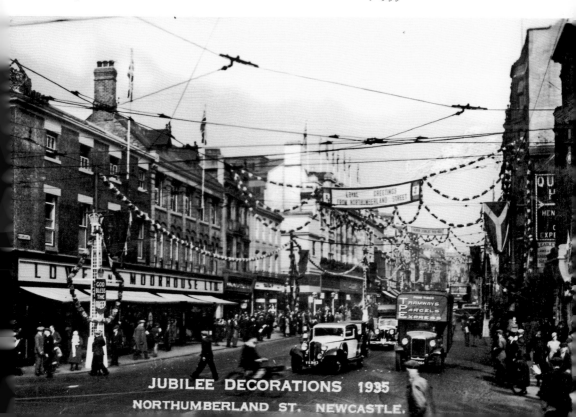

JUBILEE DECORATIONS 1935
NORTHUMBERLAND ST. NEWCASTLE.

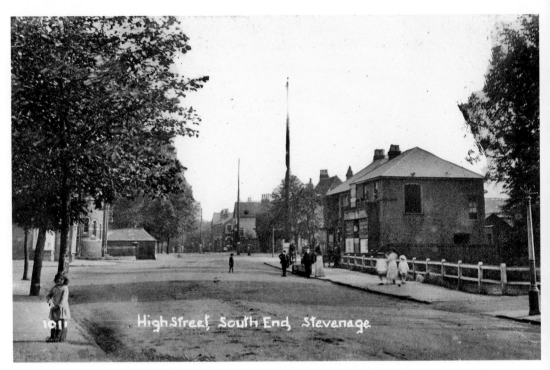

High Street South End, Stevenage

Above: Little remains of Stevenage's High Street. Until recently, this area was known as South End; the crossroads at the bottom was replaced by an elevated junction and underpass in 1976. *Below*: Other parts of the High Street have survived more successfully. The White Lion embraces modern travel by offering a 'motor garage' to customers, with inspection pit, and selling petrol alongside the more usual pub fare. Also note the enormous and invasive telegraph poles.

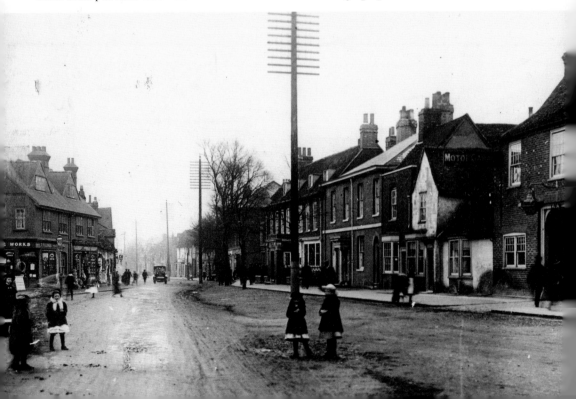

Above: This photograph shows another closed pub, this time Stevenage's George and Dragon; today it is a restaurant. *Below*: Stevenage's Middle Row. This was erected sometime in the sixteenth century to fill the wide expanse of the medieval high street. Some have survived, though much was demolished in 1938, including the home of Stevenage's last town crier.

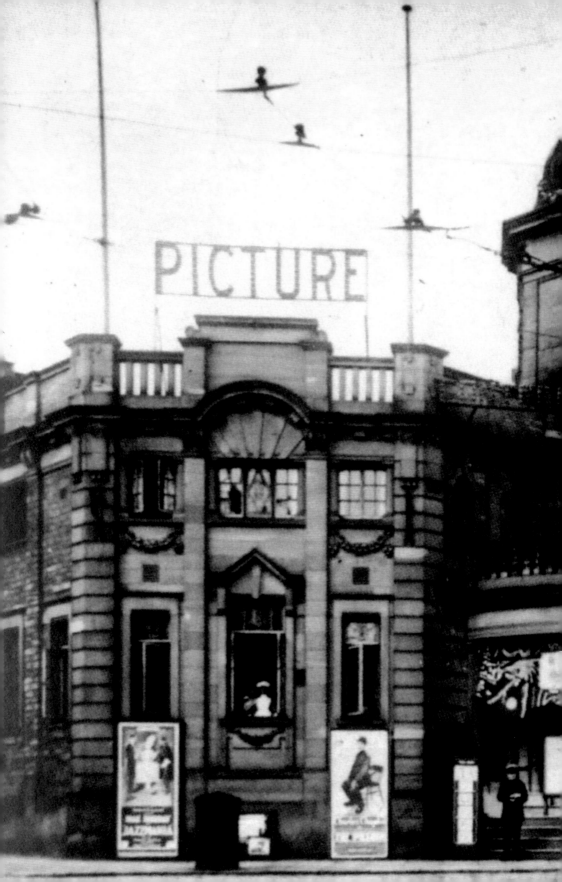

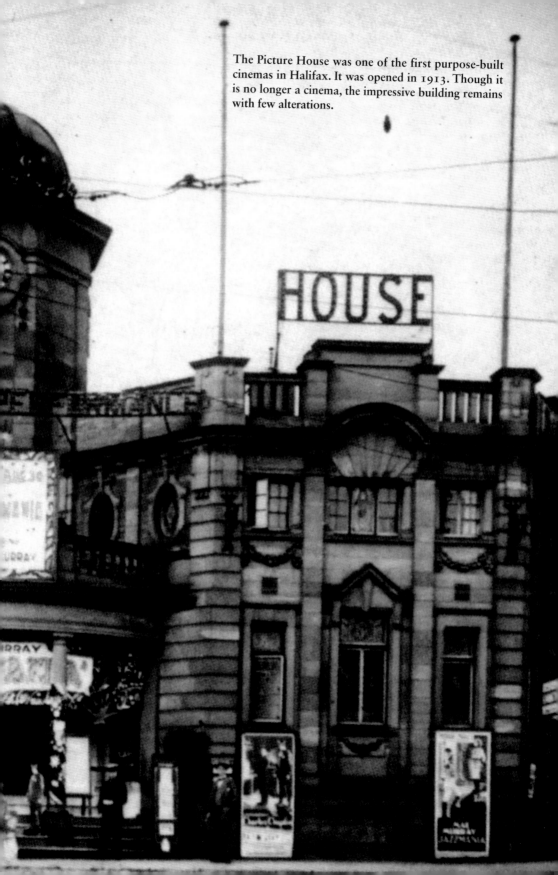

The Picture House was one of the first purpose-built cinemas in Halifax. It was opened in 1913. Though it is no longer a cinema, the impressive building remains with few alterations.

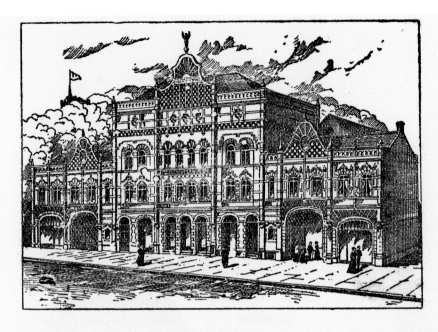

Proprietor and Manager = *J. MAURICE CLEMENT.*

" I hold the world but as the world Gratiano."

" A Stage, where every man must play a part."

Merchant of Venice, Act I, Scene I.

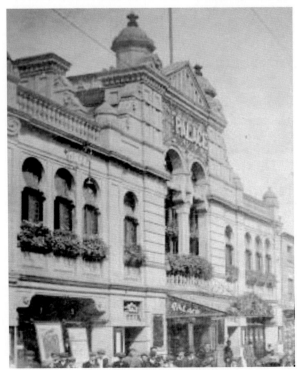

Above: An image from a 1901 programme for the Opera House, Castle Hill, Dudley. The ornate building was sadly destroyed in a fire in 1936.

Left: The grand Palace Theatre was opened in Leicester's Haymarket in 1901. Imposing theatres were a reminder to visitors of the wealth and stature of the city; this one was demolished in 1959.

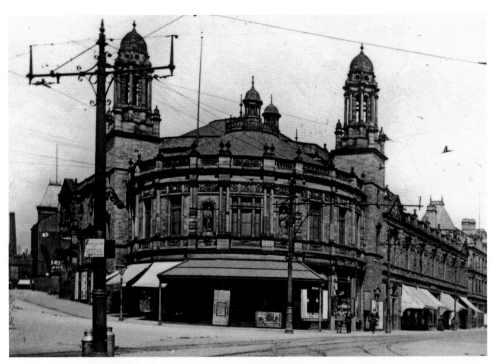

Another Halifax institution, this one with a happier ending. The Victoria Theatre opened in 1906, and is still in situ today at the southern entrance to the town centre, with very little external change.

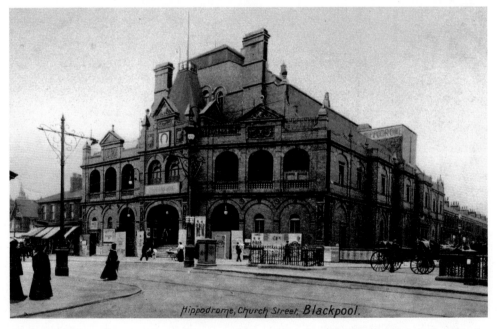

Blackpool's Hippodrome, so named in 1900; before this it was a ballroom/music hall under the name of the Empire Theatre. It housed a circus as the Hippodrome, later becoming a cinema and variety theatre. Until 1998 there was a cinema still on the site, though not in the same building; it is now the Syndicate superclub.

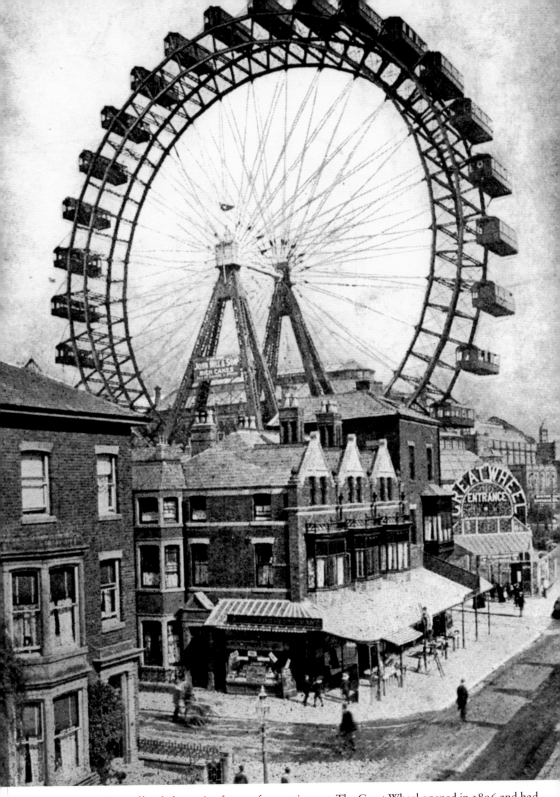

Blackpool has long offered alternative forms of entertainment. The Great Wheel opened in 1896 and had its entrance on the corner of Coronation Street and Adelaide Street. It was closed in 1928.

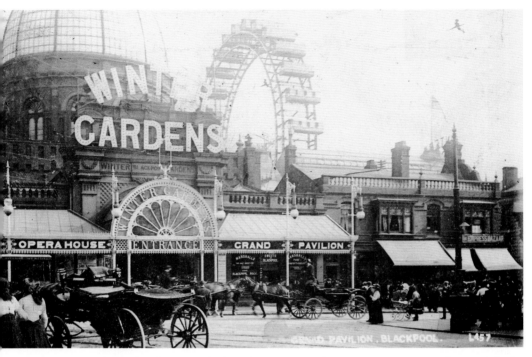

The Winter Gardens, Church Street, Blackpool. It was opened in 1876 as an open-air skating rink; the main entrance, with its 120-foot-high glazed dome, along with a concert hall and floral hall opened two years later. The Great Wheel is visible in the background.

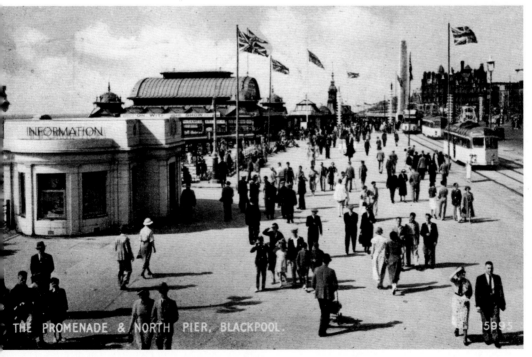

Blackpool's busy Promenade and North Pier in the late 1940s.

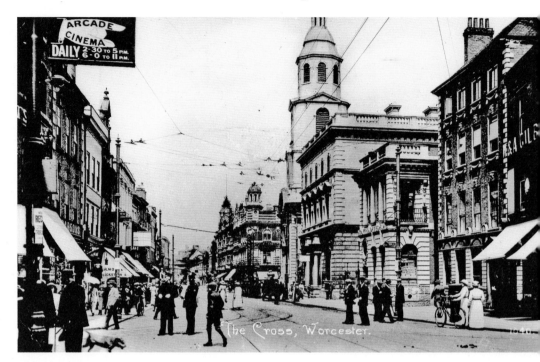

This postcard from 1917 shows a busy Worcester city centre. The sign in the top right points towards the Arcade Cinema, which opened sometime between 1912 and 1916 and is no longer there.

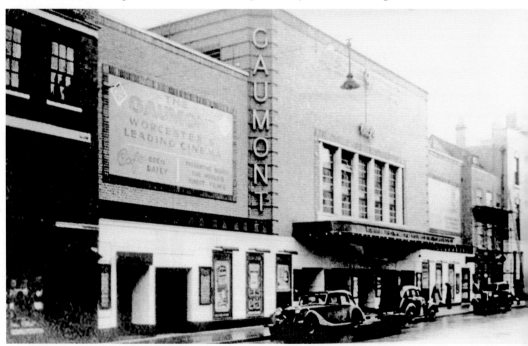

Worcester's Gaumont cinema, a few decades later, which opened in 1935 and was replaced by a bingo hall in later years. It also doubled as a theatre, hosting concerts by Jimi Hendrix, The Beatles, The Rolling Stones and David Bowie, among others.

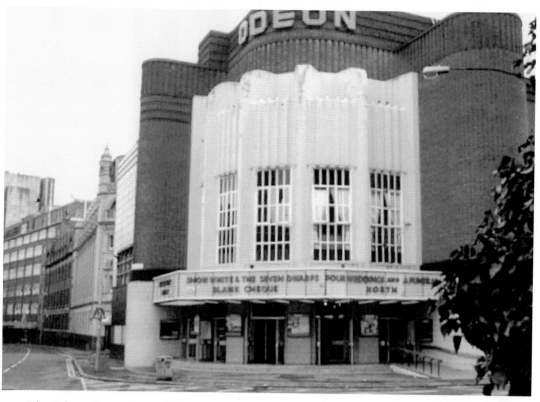

The Odeon, Queen Street, Leicester, which opened in 1938. A big building in its heyday, it is today dwarfed by the new cinema complex across the street; it is now a conference centre.

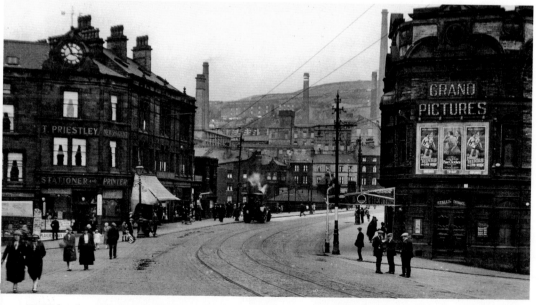

Halifax, showing North Bridge and the Grand Theatre, on the right. This was demolished in 1957 after a ton of ornamental plaster fell from the ceiling on to the pit and stalls.

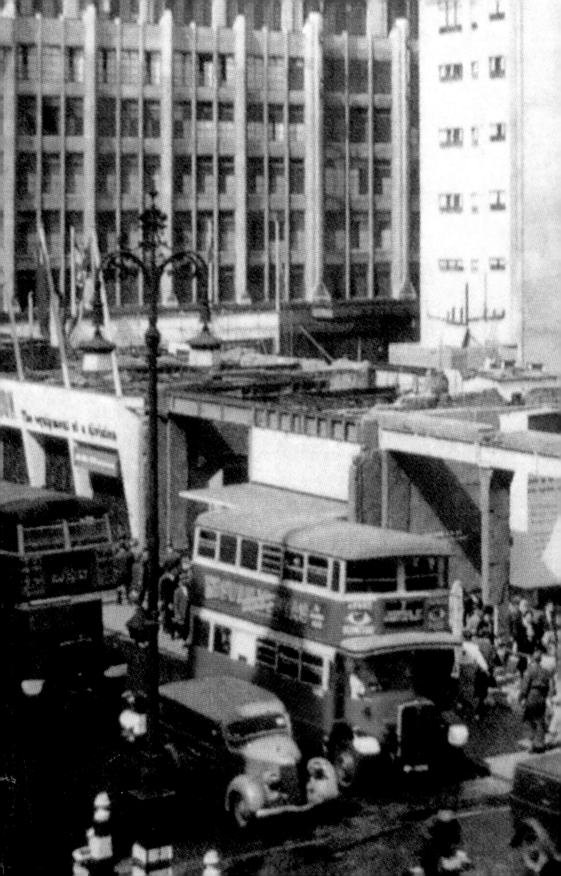

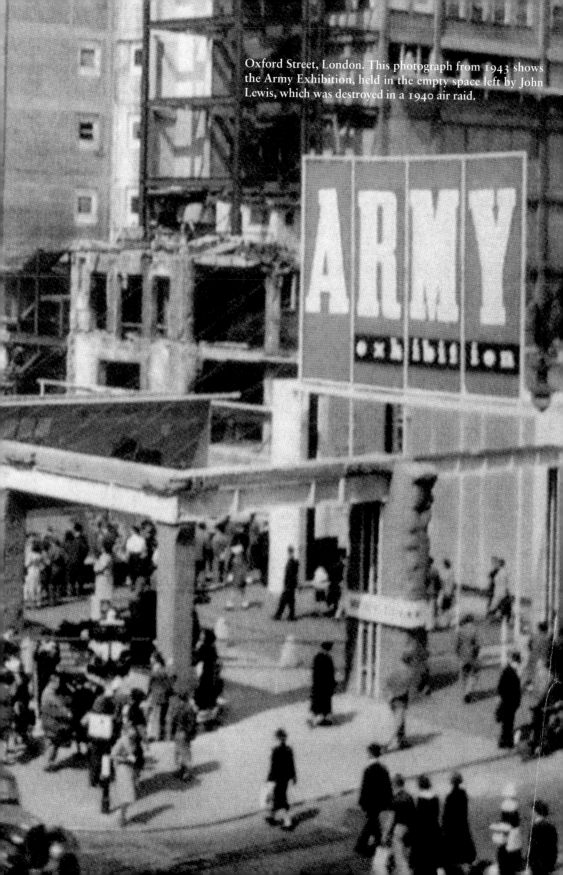

Oxford Street, London. This photograph from 1943 shows the Army Exhibition, held in the empty space left by John Lewis, which was destroyed in a 1940 air raid.

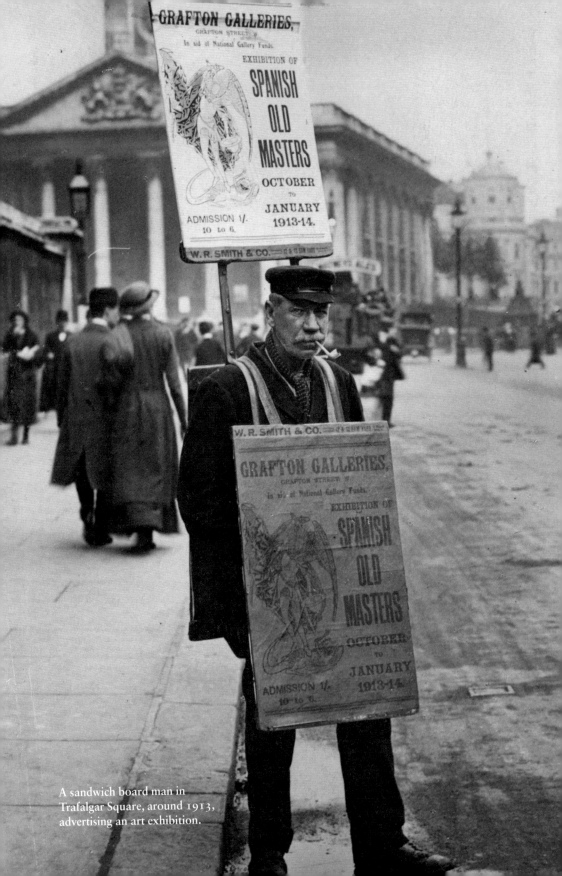

A sandwich board man in
Trafalgar Square, around 1913,
advertising an art exhibition.

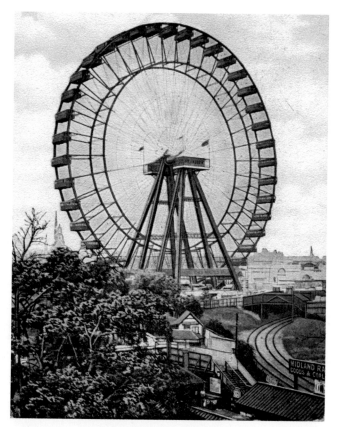

Not the London Eye, but an earlier giant Ferris wheel in London, pictured here in 1901. This was erected in 1894 at Earl's Court, and would have dominated London's skyline; the twenty-minute ride would have offered unparalleled views of the city.

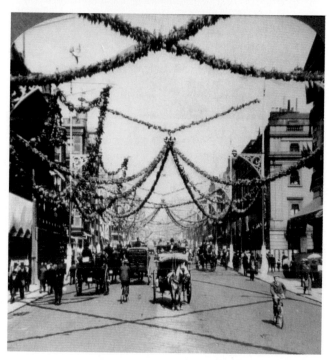

The decorations here are in honour of Queen Victoria's Diamond Jubilee in 1897, with garlands strung along the processional route through St James's Street.

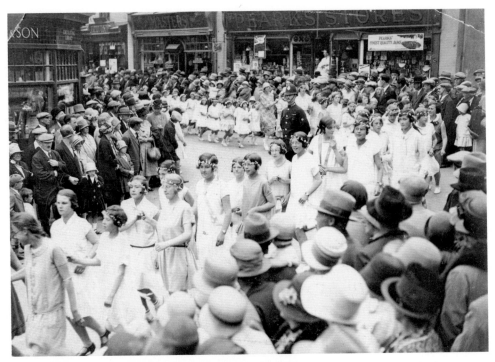

St Austell Feast Week, 1928. The traditional Flora Dance is surrounded by a crowd of spectators at the corner of Church Street.

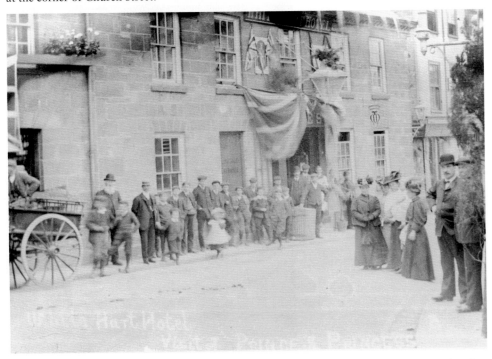

St Austell's White Hart Hotel, decorated for the 1909 visit of the Prince and Princess of Wales. The White Hart is still in business today.

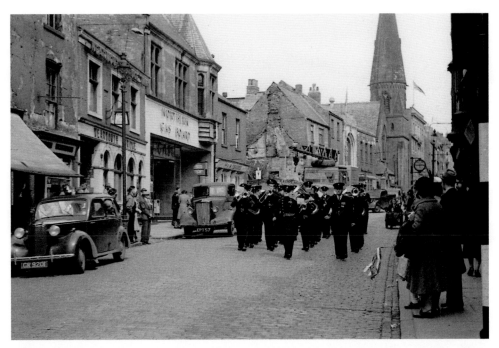

A Durham police band march down Claypath towards the Market Place in 1951. The spectacle has attracted a more modest crowd.

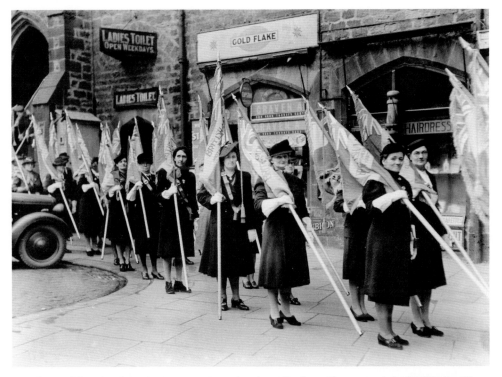

Members of the British Legion's women's section from Durham County wait in the Market Place, 1946. The annual meeting in the town hall was broken by a short service in St Nicholas' church.

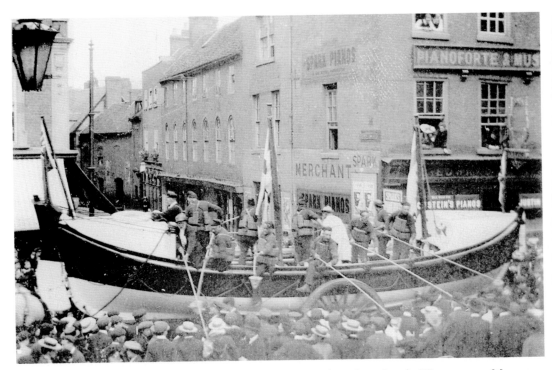

Above: A procession along Worcester's Church Street in 1905, here featuring the Weston-super-Mare lifeboat and crew. An annual lifeboat procession was held in Worcester for many years. *Below*: A different crowd fills the streets in this 1914 postcard, showing military recruitment in St John's. The message on the back adds a particular poignancy to this scene: 'Just a line to say that Tom has enlisted in the RAMC and goes to Aldershot on Monday.'

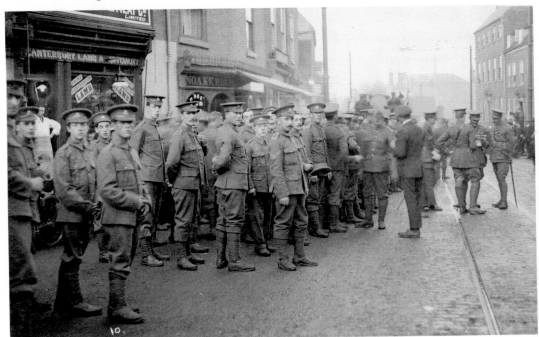

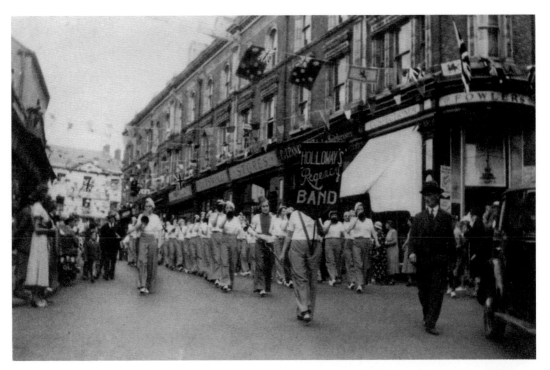

Above: This 1930 picture of Stroud's Kendrick Street shows Holloway's Regency Jazz Band on parade. Flags have been strung between the buildings.

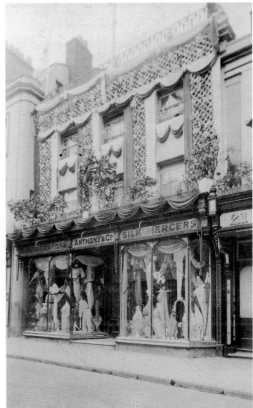

Right: The decorations adorning Anthony's Drapery Store, King Street, are thought to be in honour of either the 1911 Coronation or one of the County Agricultural Show's visits to Stroud in 1907 and 1912. Whatever the occasion, it would certainly have stood out on the street.

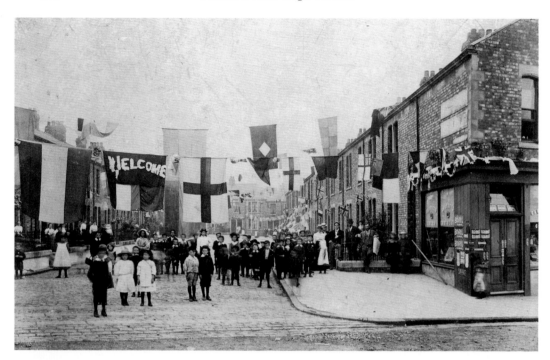

Newton Street, Gateshead, in 1902. It is unclear again what the celebrations are for; theories include the coronation of Edward VII and the welcoming home of local soldiers from the Boer War.

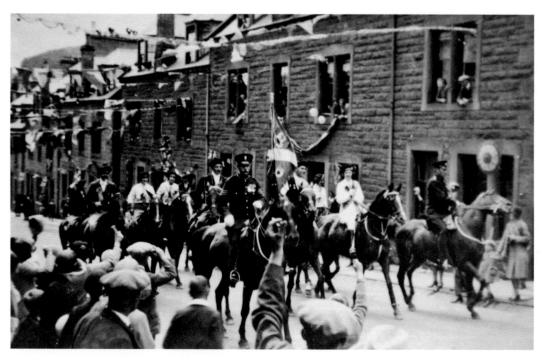

Scott Street in Galashiels was the setting here for the first ever Braw Lads' Day in 1930, which saw a parade of horses make its way around the streets and celebrated the history of the town.

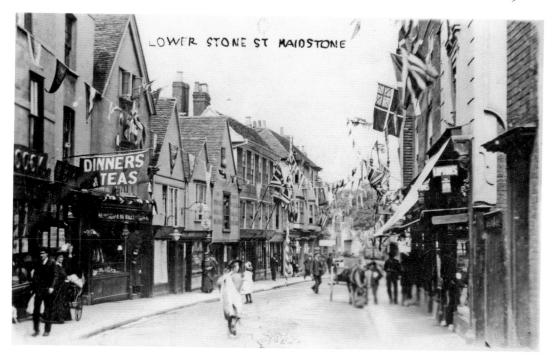

Lower Stone Street, Maidstone, during the 1910 Cricket Week. Again, flags are hung from buildings and strung across the street in what must have been a colourful and vibrant scene.

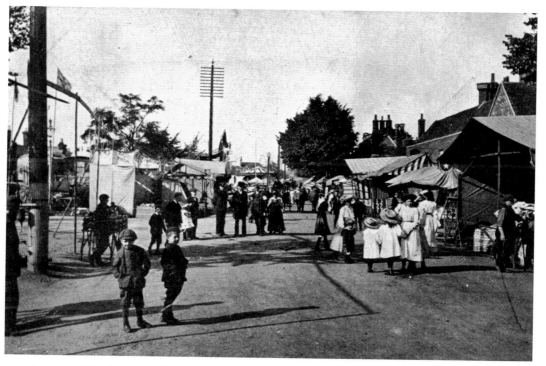

Stevenage Fair in 1907. This ancient fair, which dates back nearly 800 years, is held annually on Stevenage's High Street.

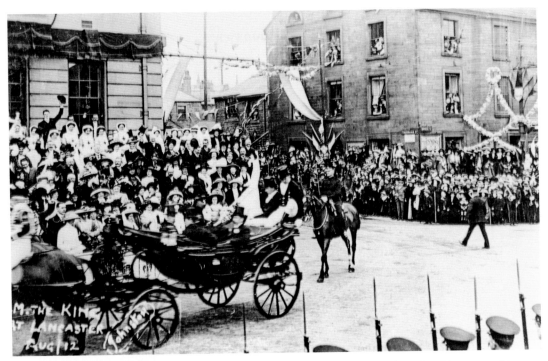

The 1912 royal visit to Lancaster by George V. A huge crowd has turned out for this memorable occasion.

A rather damp Sunday Armistice Parade in St Austell, around 1970. The brass band assembled around the war memorial is just about visible.

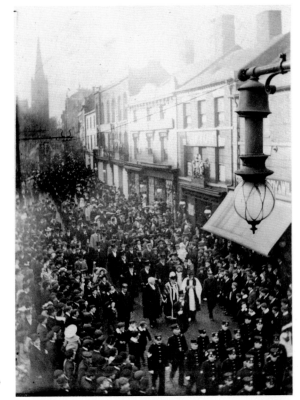

Right: An early twentieth-century parade in Dudley's High Street, thronged with spectators. The mayor is visible in the centre, preceded by a large police escort.

Below: Uxbridge Square in Anglesey's Menai Bridge, 1890. The flags celebrate the coming of age of the Earl of Uxbridge, in whose honour the square was named.

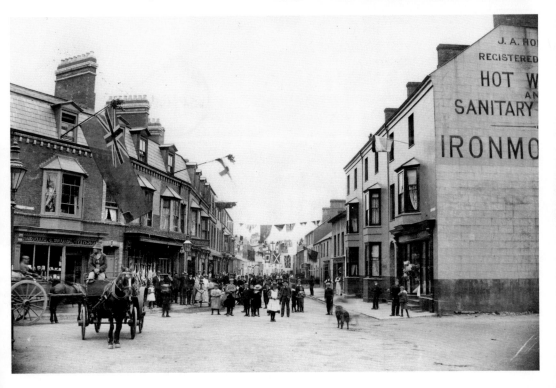

A far more exotic parade as the circus makes its way down Llangefni High Street in the early twentieth century. Excited children run after the carriage, and groups of spectators are gathering.

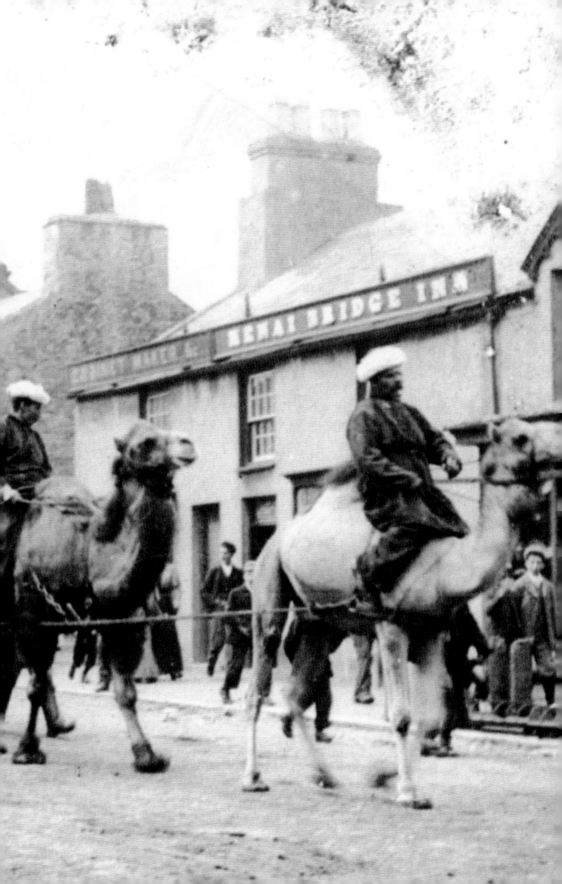

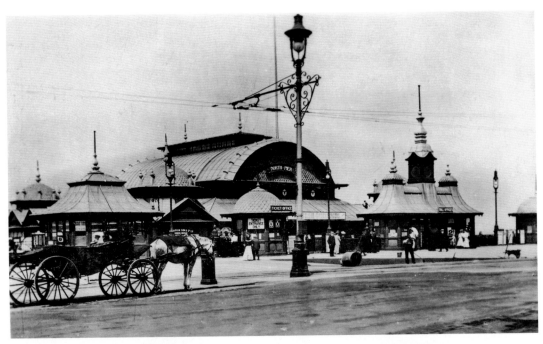

Blackpool's North Pier, seen here in around 1905 and almost deserted. At this point, entrance was only 2*d*. The pier itself was originally intended purely as a platform for people to 'promenade', and was opened in 1863. Many improvements and modifications have been made since then.

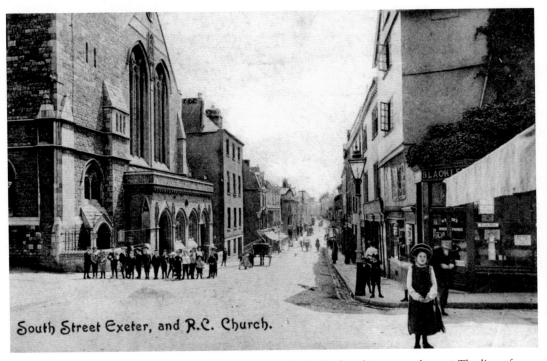

Exeter's South Street, outside the Sacred Heart Roman Catholic church in around 1906. The line of children in the road is perhaps a Sunday school outing.

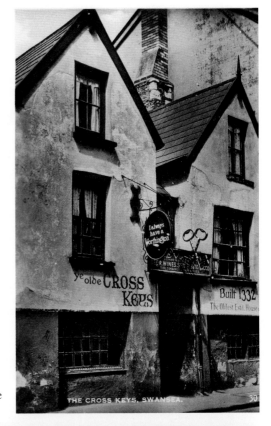

Right: The Cross Keys Inn, Swansea, around 1920. This inn is the oldest occupied building in the city and was originally built in 1332 as the Hospital of the Blessed David of Swansea.

Below: Swansea Market in 1916, thronged with buyers and producers from all around Swansea and Gower. Market day was not only a shopping opportunity but also a social event, enabling people to catch up on any gossip from the nearby areas.

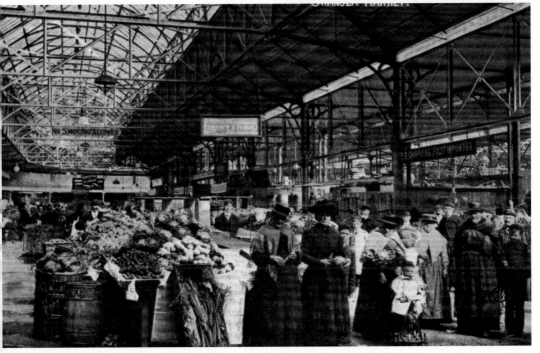

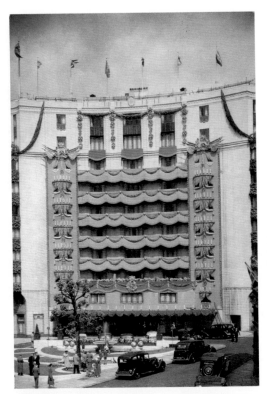

Left: The Dorchester Hotel, London, lavishly decorated in 1953 for the coronation of Elizabeth II.

Below: There is definitely something missing from this view of Piccadilly Circus in London, 1943. The Eros statue has been moved for safekeeping during the war. The adverts also reflect the times; there are charity appeals and an offer for 'free insurance for fire watchers'.

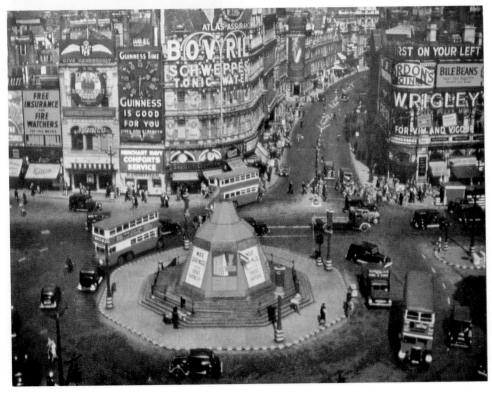

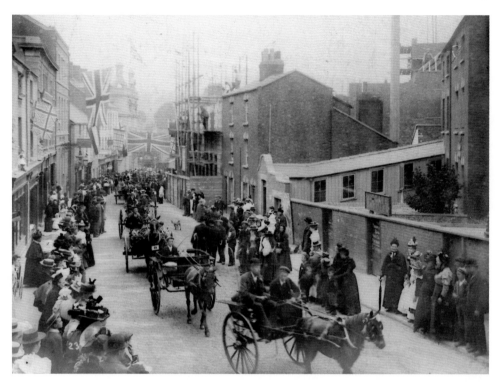

Above: A procession in Stroud's Russell Street, thought to be celebrating Queen Victoria's Diamond Jubilee in 1897. There is again an air of enthusiastic patriotism, with flags hanging from shops and houses, and spectators lining the street. *Below*: The former police station and magistrate's court, decorated extensively in honour of an Agricultural Show visit.

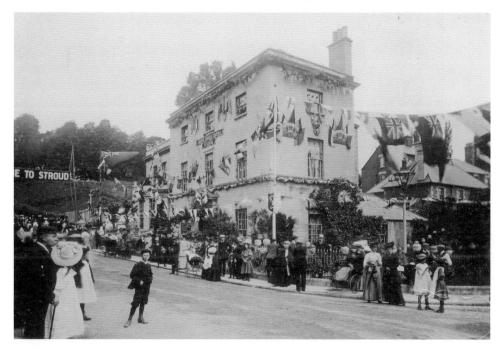

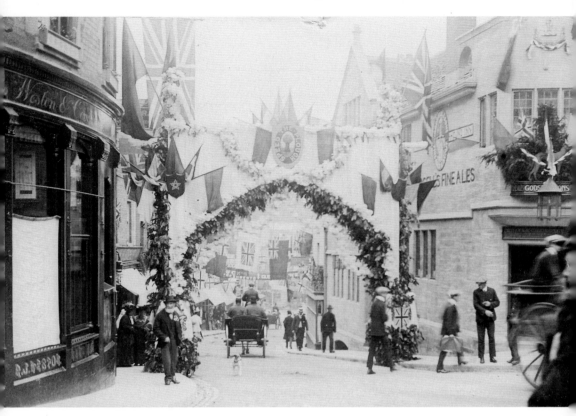

A view from the top of Stroud's Gloucester Street, 1907, decorated for that year's County Agricultural Show visit.